DUNDEE
IN
50
BUILDINGS

BRIAN KING

AMBERLEY

How to Use This Book

The buildings are listed in chronological order by date of construction, which indicate original building dates and any subsequent significant rebuilding. The map enables you to find the buildings within the book as the key uses the same numbers as the text. Before visiting any of the buildings it is advisable to check their websites for opening hours and access.

First published 2018

Amberley Publishing, The Hill, Stroud
Gloucestershire GL5 4EP

www.amberley-books.com

Copyright © Brian King, 2018

The right of Brian King to be identified as the Author of this work has been asserted in accordance with the Copyrights, Designs and Patents Act 1988.

Map contains Ordnance Survey data © Crown copyright and database right [2018]

British Library Cataloguing in Publication Data.
A catalogue record for this book is available from the British Library.

ISBN 978 1 4456 6492 7 (print)
ISBN 978 1 4456 6493 4 (ebook)

Origination by Amberley Publishing.
Printed in Great Britain.

Contents

Map 4

Key 6

Introduction 7

The 50 Buildings 8

Acknowledgements 96

Select Bibliography 96

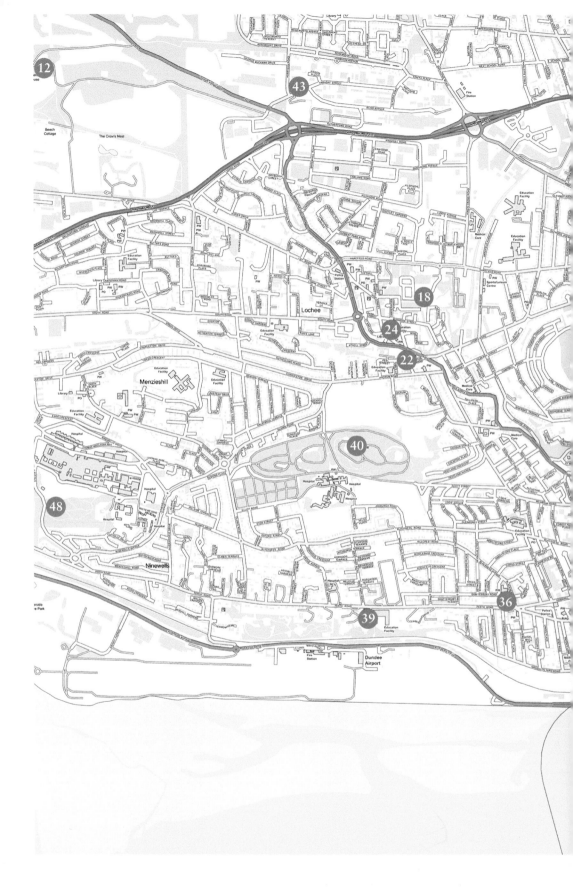

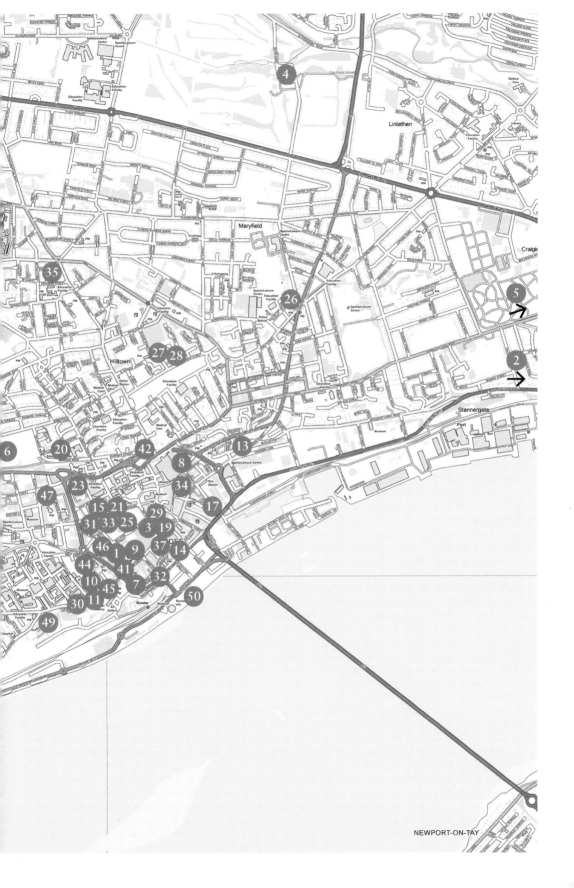

Key

1. The Old Steeple (*c.* 1480)
2. Broughty Castle (1496)
3. Gardyne's Land (*c.* 1560)
4. Mains Castle (1582)
5. Claypotts Castle (1588)
6. Dudhope Castle (*c.* 1590)
7. St David's Halls (*c.* 1600)
8. St Andrew's Church (*c.* 1774)
9. The City Churches (1789)
10. Morgan Tower (*c.* 1790)
11. Nethergate House (1790)
12. Camperdown House (1824)
13. Dens Works (1828)
14. Exchange Coffee House (1830)
15. High School of Dundee (1834)
16. The Vine, No. 43 Magdalen Yard Road (1836)
17. Custom House (1843)
18. Camperdown Works (1850)
19. St Paul's Cathedral (1855)
20. Dundee Royal Infirmary (1855)
21. The Royal Exchange (1856)
22. Lochee Station (1861)
23. Sheriff Court (1863)
24. Immaculate Conception Church, Lochee (1866)
25. The Albert Institute (1867)
26. Morgan Academy (1868)
27. St Salvador's Church (1868)
28. Faces Land (1871)
29. Clydesdale Bank (1876)
30. Queen's Hotel (1878)
31. General Post Office (1898)
32. Mathers Temperance Hotel (1899)
33. The Courier Building (1902)
34. The King's Theatre (1909)
35. Coldside Library (1909)
36. Blackness Library (1909)
37. The Caird Hall (1923)
38. Whitehall Theatre (1929)
39. Harris Academy, Perth Road (1931)
40. Mills Observatory (1935)
41. Green's Playhouse (1936)
42. Dallfield 'Multis' (1966)
43. Olivetti Building (1972)
44. The Rep (1982)
45. Dundee Contemporary Arts (1999)
46. Overgate Centre (2000)
47. Dundee Central Mosque (2000)
48. Maggie's Centre (2003)
49. Building 01, District 10 (2014)
50. V&A Museum of Design Dundee (2018)

Introduction

While evidence points to the earliest settlements in the area having been founded between 6,000 and 8,000 years ago, Dundee as we know it is traditionally said to have come into being in the late twelfth century when it was founded by David, Earl of Huntingdon, brother of King William the Lion. Huntingdon founded the Church of St Mary the Virgin, the predecessor of the City Churches, whose tower, known as the Old Steeple, is Dundee's oldest surviving building.

The Old Steeple is our starting point for a journey through Dundee's history told through fifty of its buildings. Along the way we will look at the few surviving early buildings, those associated with Dundee's time as a thriving seaport, those shaped in the heat of the Industrial Revolution and those which have played a part in the artistic, religious and cultural life of the city.

Any selection such as this is, of course, completely subjective and readers will no doubt have their own ideas as to which buildings should or should not have been included. By way of explanation, some have been included for their architectural merit alone, while others would not earn their place on that basis but are here for the part that they have played in the history or cultural life of the city. Some have been included as a representative of a type of building. It would be possible, for example, to fill a book with the churches and former churches in the city, and so only a relatively small number can be included. Similarly, while it would be possible to create a list based on architectural merit alone, it would seem remiss not to include at least a representative tenement or factory.

Many buildings with historic or architectural merit in Dundee have been lost over the years, including the William Adam-designed Town House, which was demolished in the 1920s, while redevelopments in the 1960s and '70s saw the removal of much of the historic heart of the city. This selection has been restricted, though, to those buildings which are still standing and can be seen or visited today.

It is to be hoped that this book will encourage the reader to find out more about the history of Dundee's buildings, or perhaps simply look again at the buildings and appreciate some of their finer details. There will be many, for example, who pass by the old GPO building every day but have never noticed the angels that adorn its façade or who have looked at the Caird Hall on innumerable occasions but have never spotted the two sets of square pillars that bookend the rounded ones in the colonnade.

The entries are listed in chronological order to allow the story of Dundee to emerge along the way. As the city enters a new era with the opening of the V&A Museum of Design and the accompanying redevelopment of the entire waterfront area, many fine new buildings will surely be constructed in the future. It is to be hoped, however, that those that are already standing will not be neglected and Dundonians and visitors alike will take the time to appreciate them and discover the history that they conceal.

The 50 Buildings

1. The Old Steeple (c. 1480)

Dundee's oldest surviving building is the Tower of St Mary – or as it is more commonly known, the Old Steeple. The tower dates from the fifteenth century, being completed around 1480. The Old Steeple is in many ways a symbol of continuity in Dundee, having withstood the upheavals of the Reformation, several invasions of the town and the repeated destruction of the churches to which it is connected. So badly damaged was the church nave in the attack on Dundee by James Graham, Marquis of Montrose, in 1645 that for more than a century the Old Steeple stood alone as a separate structure.

When General Monck's army invaded Dundee in 1651, the town's Governor, Sir Robert Lumsden, and a few brave supporters held out in the Old Steeple for three days until Monck's men lit fires at the foot of the building and forced them out. All of them were beheaded and Lumsden's head was stuck on a spike half way up the tower, where it remained for the next nine years until it rotted away.

It is thought that the tower may once have supported a crown spire – where flying buttresses form the shape of a crown – such as that which tops St Giles Cathedral in Edinburgh today. When the building was restored in the nineteenth century, the architect Sir George Gilbert Scott proposed a design for a replacement crown spire but this was never built.

For many years it was possible to climb the 232 steps of the Old Steeple and enjoy the magnificent views from the parapet for the payment of a small entrance fee. Admission is not quite so routine these days but there are usually guided tours on selected days in the summer and these have the advantage of allowing access to other parts of the building – namely the Antiquities Room (which was once a prison), the Bell-Ringers' Room, the Belfry, the Clock Room (which houses the mechanism that drives the tower's four clock faces) and finally the Cape House on top of the tower.

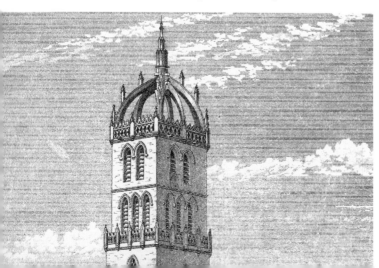

The Steeple as it might have looked with a crown spire.

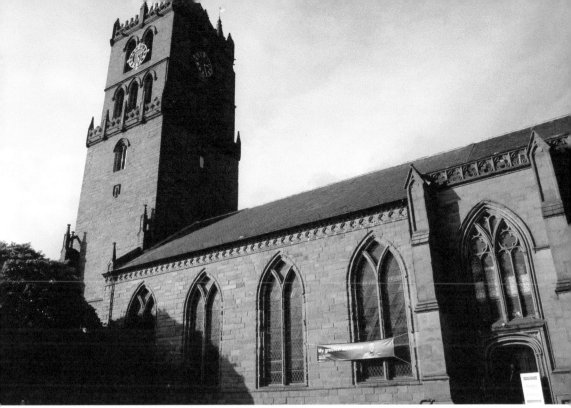

Above: The Old Steeple from the City Churches.

Right: The Old Steeple.

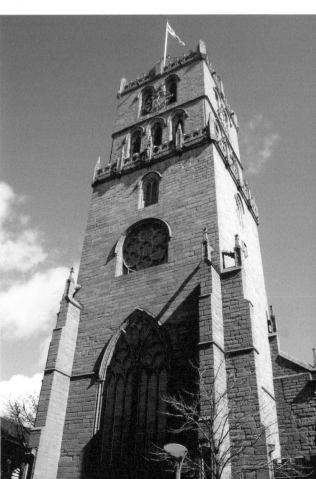

2. Broughty Castle (1496)

In 1490, the second Lord Gray was given permission by King James IV to build a castle on a strategically important site at the mouth of the River Tay. The 4th Earl of Angus had been granted a similar permission by James II in 1454 – though it is unclear if this earlier structure was ever built. When Broughty Castle was finally constructed it was typical of the period, with its principal feature being a four-storey tower.

In the sixteenth century, the Scots and the English became involved in the conflict known as the 'Rough Wooing', which followed Henry VIII's attempts to betroth his son to the young Mary, Queen of Scots. In 1547, having defeated the Scots at the Battle of Pinkie, the English captured Broughty Castle and held it for more than two years.

In 1651, during the English Civil War, General Monck attacked Broughty Castle on his way to take Dundee for the Parliamentary side. It seems that the castle was badly damaged. It was certainly derelict by 1787 when Robert Burns visited the area. He described the structure as 'a finely situated ruin jutting into the Tay'.

In 1666, the Grays had sold the castle to the Fotheringham family who owned it until 1846, when it came into the ownership of the Edinburgh and Northern Railway Company. The Crimean War and the subsequent threat of French invasion in the mid-nineteenth century saw it transferred to the War Office and a major renovation and refortification began in 1860 to the design of the architect Robert Rowand Anderson. While the main tower house remained, it was altered and its setting was significantly restructured.

Broughty Castle from the harbour.

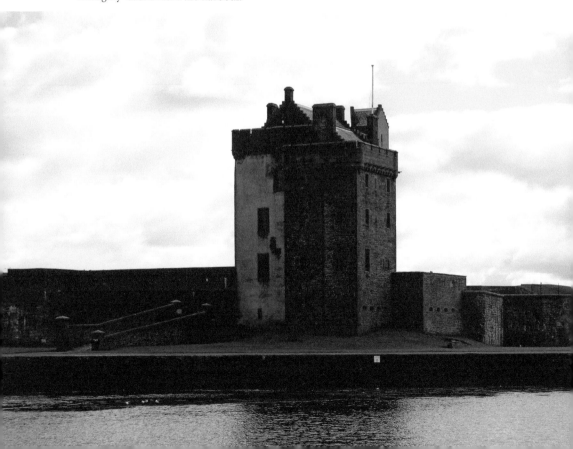

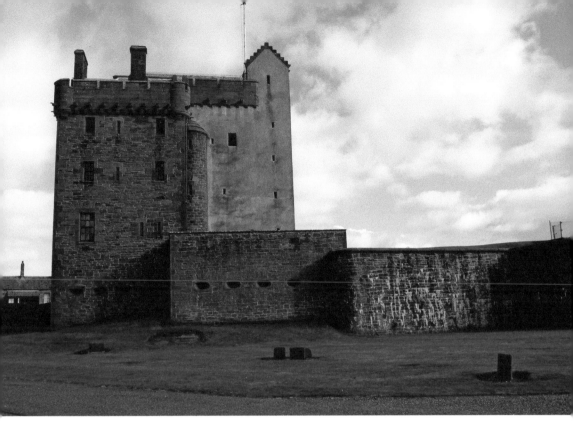

Broughty Castle.

The castle continued to be used for military purposes and at one point was the headquarters of the Tay Division Submarine Miners Royal Engineers (Volunteers). Though it was transferred to the Ministry of Works in 1935, the strategic importance of its setting which had been recognised back in the fifteenth century saw Broughty Castle returned to military use during the Second World War. Since 1969, however, it has been home to a museum. Today, the castle is under the care of Historic Scotland, while the museum is operated by Leisure and Culture Dundee.

3. Gardyne's Land (c. 1560)

So much of Dundee's architectural heritage has been lost over the years that it is truly remarkable to find Gardyne's Land, a late medieval merchant's house, surviving in the very heart of the city. The L-shaped house is the oldest domestic dwelling in Dundee and dates from around 1560 and the time of one John Gardyne. It sits, hidden from view, at the rear of a complex of historic buildings fronting the High Street. It is perhaps only because the building's great age was not readily visible that it managed to survive the Improvement Act of 1871 or the demolitions of the 1960s and '70s, which saw the destruction of so much of Dundee's architectural heritage.

The other buildings in the group are two tenements dating from the early seventeenth and late eighteenth centuries, as well as a billiard room and a shop from the nineteenth century. In 1995, excavations at the site produced evidence of habitation – including a

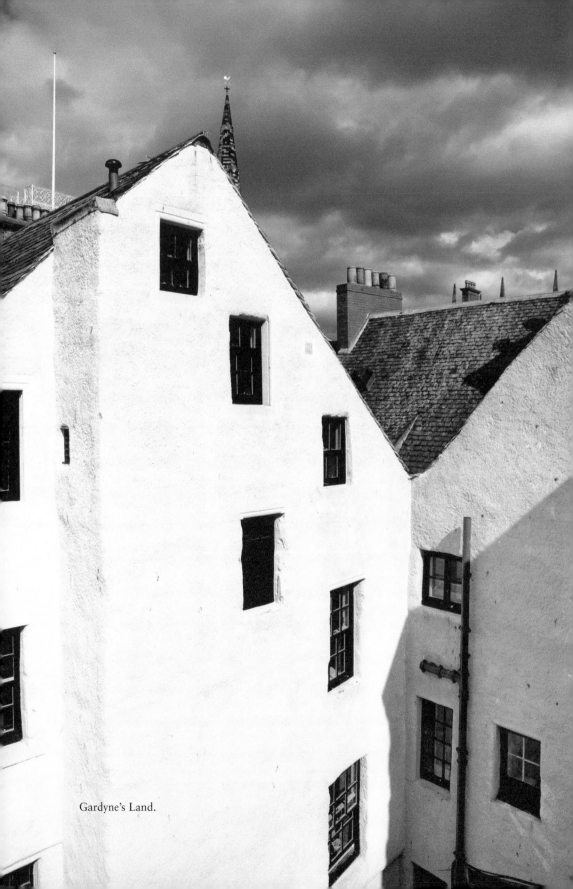

Gardyne's Land.

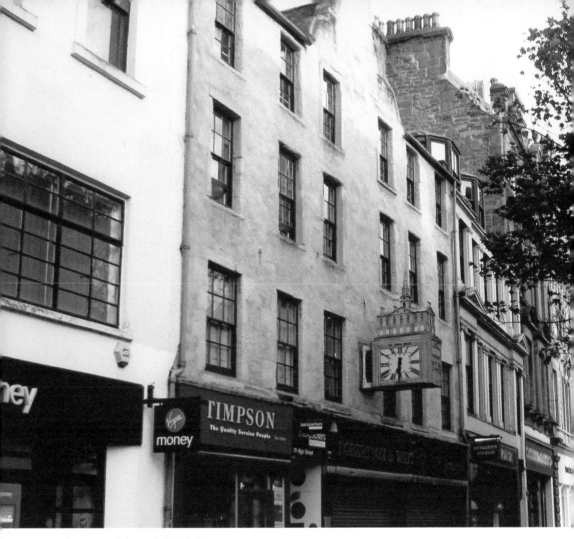

Gardyne's Land from the High Street.

well – that predates all these buildings and stretches back to the earliest days of the burgh of Dundee in the twelfth and thirteenth centuries.

In 1995 the whole complex of buildings was acquired by the Tayside Building Preservation Trust and restored in the early years of the twenty-first century. It was converted between 2005 and 2007 by Simpson & Brown architects, and now forms the Dundee Backpackers' Hostel. As well as saving these historic buildings, the award-winning conversion has given them a practical function and provided a unique lodging place for visitors to the city.

Above the High Street entrance to the hostel is a reminder of another of Dundee's historic buildings – a model of the Town House that sits atop a clock. The Town House, which stood on the opposite side of the High Street from Gardyne's Land for some 200 years, was designed by William Adam. The model was designed by William Wallace Friskin of Messrs Allan & Friskin, Castle Street, Dundee, and built by metalworkers Brown & Son of Montrose. Between the dates 1732 and 1932, it bears the inscription – 'Memory is Time'.

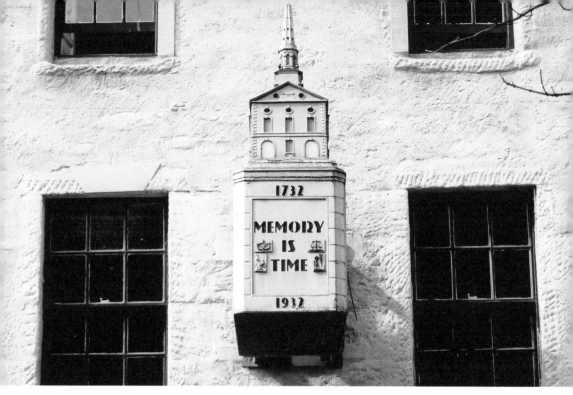

Town House Clock at Gardyne's Land.

4. Mains Castle (1582)

Mains (formerly Fintry) Castle was built in the late sixteenth century by the Graham family, who originally hailed from Fintry in Stirlingshire and brought that name with them to give to their lands near Dundee. The earliest building on the site was a hunting lodge or occasional dwelling which dates from around a century before the more substantial castle buildings.

Two date stones are traditionally said to have marked the commencement and completion of the building in 1562 and 1582 respectively. A Latin inscription over the door of a building in the courtyard translates as 'At peace and in friendship with my country and my family'. It appears that Sir David Graham, 5th Laird of Fintry and the first to use the castle as his main residence, may have lived out the last few years of his life in relative peace there but in 1593, his son, David Graham, the 6th Laird, was executed in Edinburgh for his part in a Catholic conspiracy.

Mains Castle consists of several buildings surrounding a courtyard. Its most striking feature is the 70-foot-high tower. This is unusually tall for a building of this type and appears to be designed to compensate for the castle's situation in a dip in the ground by the Gelly Burn. The castle's attractive setting is described by Dundee's most famous (or infamous) poet, William McGonagall, in his own inimitable style:

> Ancient castle of the Mains,
> With your romantic scenery
> And surrounding plains,
> Which seem most beautiful to the eye,
> And the little rivulet running by,
> Which the weary traveller can drink of when he feels dry.

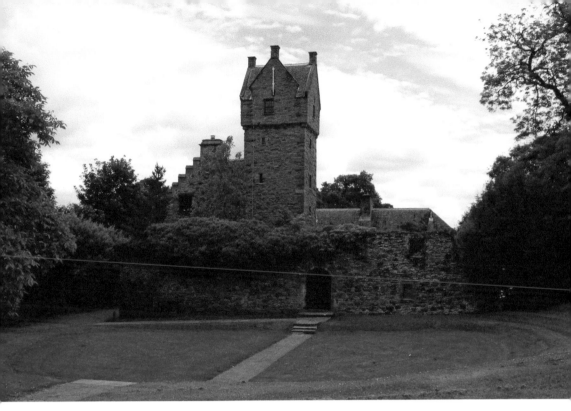

Above: Mains Castle.

Below: Mains Castle from the courtyard.

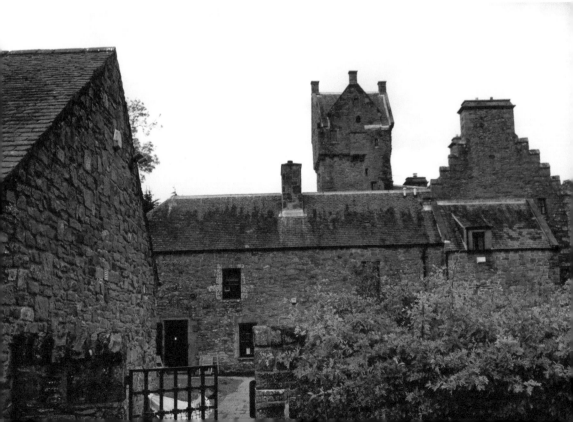

In 1789, the estate including the castle was sold to David Erskine, an Edinburgh solicitor. It remained in the Erskine family for more than a century. In 1913, it was purchased by jute manufacturer Sir James Key Caird, who later presented it to the city to be used as the public park, which still bears his name today. The castle itself fell into disrepair in the early twentieth century but was renovated in the 1980s and is now a successful function venue.

5. Claypotts Castle (1588)

The Lands of Claypotts were once part of the property of Lindores Abbey in Fife and since at least the early sixteenth century were leased to the Strachan family. The Strachans would have been in place when nearby Broughty Castle was occupied by the English in 1547, and it was perhaps this that persuaded them to build a fortified residence of their own.

Claypotts Castle was built between 1569 and 1588 and is a fine example of a sixteenth-century Z-plan tower house. The main block is a simple rectangular shape but this is somewhat disguised by the protrusion of the rounded stairwells and by the two round towers at opposite corners, each with a square gabled garret on the top. While the upper part of the building is also enhanced by an assortment of dormer windows, crow steps and chimney stacks, the basic Z-shaped design has a much more practical purpose – allowing for protective fire across the face of the main block from shot holes in the towers on either side.

Sir William Graham of Balunie purchased Claypotts from the Strachans in 1601 but in 1620 it was sold by his son, David, to Sir William Graham of Claverhouse and through him was eventually passed down to John Graham of Claverhouse, later the 1st Viscount

Old postcard view of Claypotts Castle.

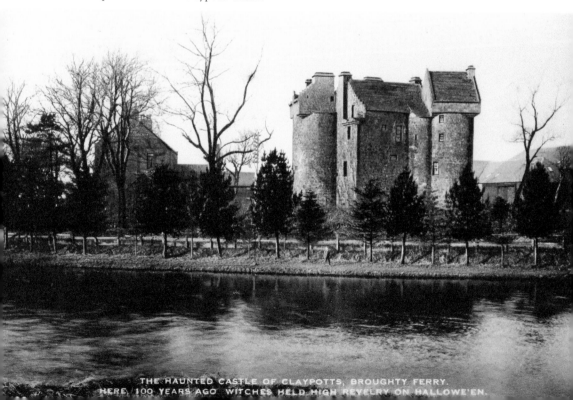

THE HAUNTED CASTLE OF CLAYPOTTS, BROUGHTY FERRY.
HERE, 100 YEARS AGO WITCHES HELD HIGH REVELRY ON HALLOWE'EN.

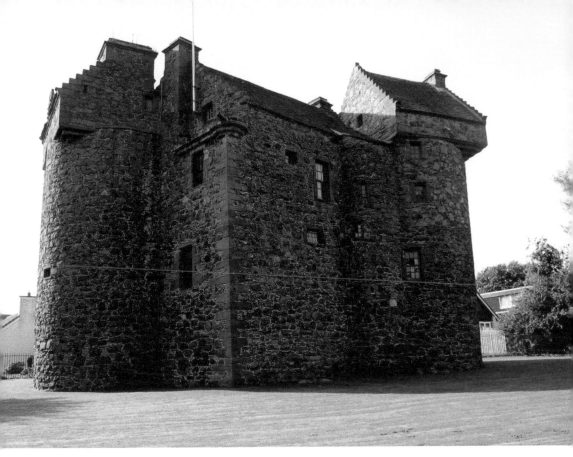

Claypotts Castle.

Dundee. Like Dudhope Castle, Claypotts Castle and its associated lands became forfeit following Claverhouse's death at the Battle of Killiecrankie in 1689. In 1694, these lands were granted by William and Mary to the 2nd Marquis of Douglas and have remained in the ownership of the Douglas family and their successors, the Earls of Home, ever since. In 1926, the Homes put Claypotts Castle under the guardianship of the Commissioners of Works and it is now looked after by Historic Scotland.

Admission to the interior of Claypotts Castle is rare and restricted to certain occasions such as 'Doors Open' days. The well-preserved exterior, however, is readily accessible since the castle's once rural location has been steadily encroached upon until it now seems somewhat out of place in a wholly urban environment.

6. Dudhope Castle (c. 1590)

In 1298, William Wallace, on behalf of King John Baliol, appointed Alexander Scrymgeour (the name derives from the nickname 'Skirmisher') to be Constable of Dundee and granted him title to lands including 'the upper field beside the town of Dundee'. The Constable was the defender of Dundee Castle, which once stood near the top of the present-day Castle Street. Following its destruction in the early thirteenth century, the Scrymgeours relocated to the 'upper field' at Dudhope.

The original structure is said to have been replaced in the mid-fifteenth century with a tower house typical of the period. The present L-shaped building dates from around 1590–1600, with the earlier tower house surviving until the 1680s.

For 370 years the castle and the office of Constable remained with the Scrymgeour family. In 1617, James VI visited Dudhope Castle, as did Charles II in 1650. In 1668, however, both castle and office passed out of the hands of Scrymgeours and were granted to Charles Maitland of Hatton. Maitland's tenure was short, though, and in 1684 the castle was sold to John Graham of Claverhouse. He set out from Dudhope Castle to embark on the campaign that ended in his death at the Battle of Killiecrankie in 1689. In 1694, the forfeited castle was granted to the Douglas family, who occupied it for around a century.

After a brief spell during which an attempt was made to run it as a woollen factory, Dudhope Castle was leased to the Board of Ordnance who, for most of the nineteenth century, occupied it as a barracks. The local council leased part of the grounds for use as a public park from 1854 and after the departure of the military in 1881 purchased both the grounds and castle. The area was opened as a public park on 28 September 1895.

The castle returned to military use during both world wars, but later fell into disrepair. Despite an attempt by suffragettes to blow it up in 1914 and the local authority considering

Dudhope Castle.

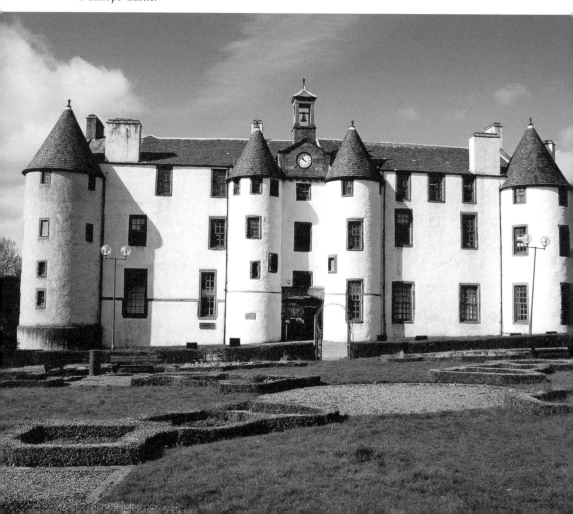

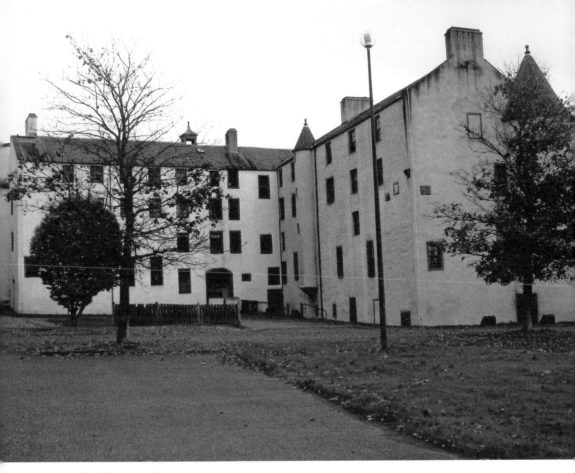

Rear of Dudhope Castle.

its demolition in 1958, Dudhope Castle survived and was renovated in the 1980s and today is used for office accommodation by Dundee City Council.

7. St David's Halls (c. 1600)

Gardyne's Land provides a model of how to effect the practical restoration and preservation of some of Dundee's oldest buildings. Sadly, a similar plan has not yet been put into action in respect of the city's other hidden survivor from the pre-1700 era. The building known as St David's Halls, or St David's Rooms, lies tucked away at the back of a courtyard behind the street front of the Nethergate. The lower portions of the structure date from the beginning of the seventeenth century with its upper floors having been rebuilt and extended in the following century and later. An archway leads to the garden beyond, which stretches down towards Yeaman Shore. At the time that this archway and the other remaining original parts were built Yeaman Shore would have, as its name suggests, been on the banks of the River Tay.

By the early years of the twenty-first century the building was in poor repair and considered to be at risk. A grant from Dundee Historic Environment Trust in 2008 helped to make the structure wind and watertight, but the full-scale restoration and re-imagining that this building requires so far remains elusive.

Above: St David's Halls from the Nethergate.

Below: St David's Halls from Yeaman Shore.

8. St Andrew's Church (c. 1774)

As its name implies, the Cowgate was once the principal route along which cattle were driven to market in Dundee and even in the early 1770s, the area was still on the fringes of the burgh. That the town was expanding in this period, though, is evidenced by two things – the demand for another church and the appointment of Samuel Bell as burgh architect.

The town council refused to contribute to the building of what was to become St Andrew's Church and the money was instead raised by the Trades Corporations of Dundee – the Nine Incorporated Trades (Bakers, Cordiners (shoemakers), Glovers, Tailors, Bonnetmakers, Fleshers (butchers), Hammermen, Weavers and Dyers) and the Three United Trades (Masons, Wrights and Slaters).

The foundation stone was laid on 4 June 1772 and the building was constructed to a design by Samuel Bell reputedly adapted from plans by James Craig, designer of Edinburgh's New Town. The rectangular church is built in rubble and has a greater degree of decoration than is common in Presbyterian churches of the period, including two large Venetian windows with Ionic pilasters and swags above. The tower with its classical steeple is built in the style of the Aberdeen-born architect James Gibbs and rises some 139 feet, narrowing as it progresses. The church was completed in 1774.

St Andrew's Parish Church. *Inset*: Nineteenth-century image of St Andrew's Parish Church.

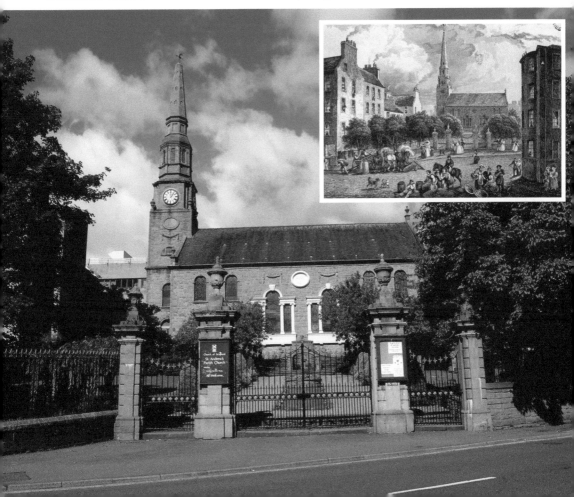

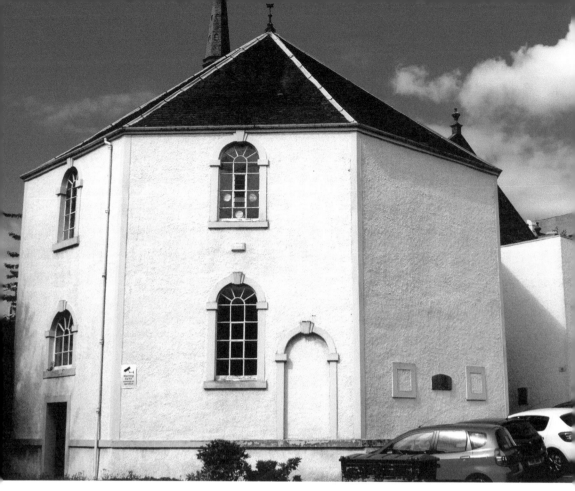

The Glasite Church.

In the grounds of St Andrew's is an octagonal building known as the Glasite or Kail Kirk. Completed in 1777, this was once the home of the sect founded by Revd John Glas and acquired its nickname from their practice of sharing meals after services. It was acquired by St Andrew's in 1973.

St Andrew's is still an active place of worship today but its past is readily visible. The Trades' role in the building of the church is recorded in the oval plaque on the front of the building and in several stained-glass windows. The annual ceremony of 'Kirkin' of the Trades' still takes place each year. The formal gardens on the rising ground, too, give a glimpse back to its semi-rural origins.

9. The City Churches (1789)

The Church of St Mary the Virgin was founded around 1190 by David, Earl of Huntingdon, brother of King William the Lion. Originally outwith the boundary of Dundee, it was known as St Mary's in the Fields or simply 'the kirk in the fields' and was once the largest parish church in Scotland. The building suffered badly in the various invasions of Dundee between the thirteenth and seventeenth centuries and the church was destroyed and rebuilt several times.

Following the Reformation, each section of the church that was rebuilt became home to a separate congregation. St Mary's Kirk at the east end of the building was the first to be completed and another church known as the South Kirk was later established in the south transept. In the mid-eighteenth century, the north transept was rebuilt and North or Cross Church was founded there. Finally, the nave was rebuilt to accommodate a fourth congregation, St Clement's (or Steeple) Kirk. The four churches were completely separate entities but shared one bell tower in the shape of the Old Steeple. The poet and humorist Thomas Hood, who lived in Dundee in the early nineteenth century, summed up the situation in this way:

> And four churches together with only one steeple,
> Is an emblem quite apt of the thrift of the people.

Today it is only Samuel Bell's late eighteenth-century Steeple Church that survives of the four churches to which Hood refers.

Early in the morning of Sunday, 3 January 1841 a fire broke out in the passage between the South Church and the Steeple Church. The fire spread quickly and soon engulfed the building, burning until the following evening. The wave of destruction had not only affected the structure itself but had destroyed the priceless Burgh Library, which contained many ancient manuscripts.

The Cross Church found accommodation elsewhere while the two remaining churches were rebuilt to designs by William Burn in the 1840s. Both St Mary's and the Steeple Church remain active places of worship today, while the former South Church is now the Mary Slessor Centre.

The City Churches before the fire of 1841.

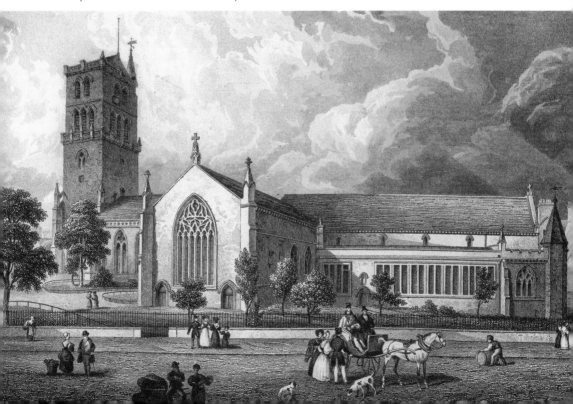

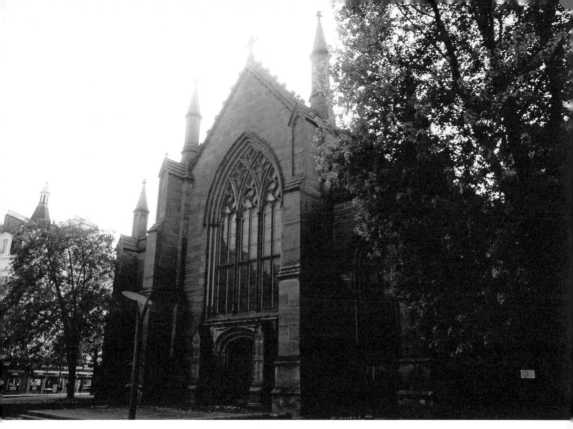

Above: Dundee parish church (St Mary's).

Below: Old postcard view of the City Churches.

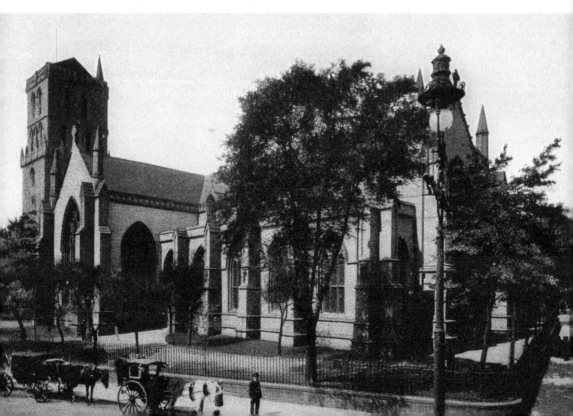

10. Morgan Tower (c. 1790)

The buildings at Nos 135–139 Nethergate contain a feature unique in Dundee in the shape of a projecting bow-fronted tower. The Morgan Tower was built around 1790 by Samuel Bell for one Daniel Morgan of Westfield. It has been said that some of its more unusual features – such as the ogee-shaped roof with its crescent moon weathervane and the Venetian-style windows – were included at the behest of the seafaring Morgan who had seen such things on his travels. The windows, at least, would appear likely to have been suggested by Bell, who had often included a similar style on other buildings, such as St Andrew's Church. Whether or not it incorporated his ideas, it may well be that Morgan himself never saw the completed building as he died in May 1791 on a voyage from St Helena to Madras.

There has been much speculation that the Morgan Tower pre-dates the late eighteenth century and that Bell had merely renovated an existing building. When the flats were advertised for rent by Morgan's widow in 1797, however, they were still being described as part of 'that new tenement of land in the Nethergate'. There remains, though, the possibility the building incorporated part of a previous structure. Dundee's sixteenth-century hospital (rebuilt in 1679) was in this area on the burgh's western fringes. It was partly demolished around 1790 and some of the materials may have been reused. Excavations at Morgan Tower

The Morgan Tower.

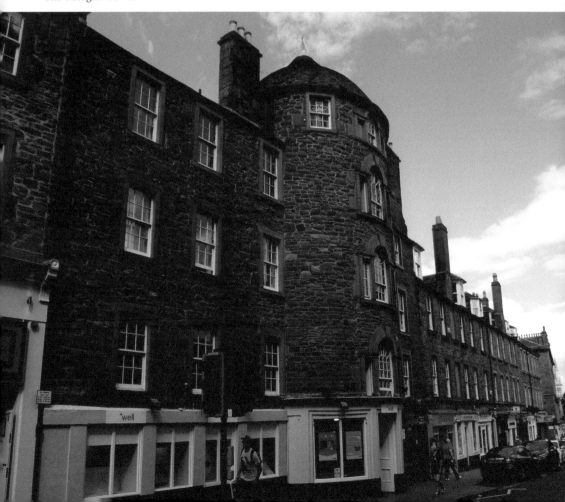

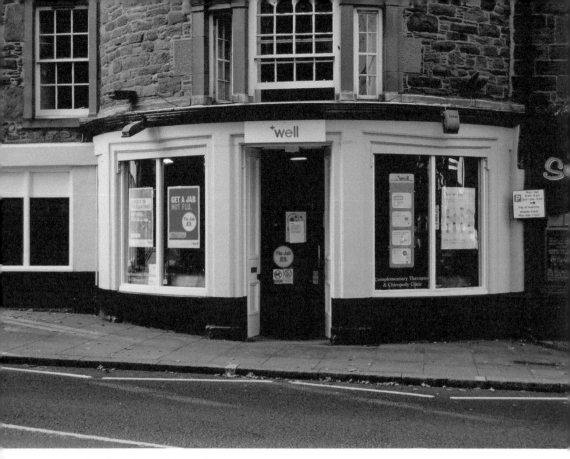

Chemist's shop at Morgan Tower.

in 1999 uncovered evidence of human remains dating from the medieval period, suggesting that this was once the site of the hospital's graveyard. The tower today maintains a link to the medical profession as its ground floor has been home to a chemist's shop since the 1870s.

The rumour of greater antiquity for the tower may simply derive from its rounded appearance, which people in the nineteenth century would have associated with some of the oldest buildings then existing in Dundee such as Dudhope Castle, General Monck's lodgings at the Overgate and the Pierson Mansion in Crichton Street. Indeed, the tower was often called 'Morgan's Castle' in this period.

11. Nethergate House (1790)

Alexander Riddoch was one of the most important and controversial figures in the history of Dundee. He was Provost of the town on eight separate occasions, the first beginning in 1788 and the last ending in 1818 – though in reality he was always in control in this period. He was described in an obituary as 'alternating provost and permanent leader' and his rule was described as 'quite absolute'.

In his favour, Riddoch's legacy can still be seen in the city today in the shape of Crichton Street, Castle Street and Tay Street, all of which he was instrumental in opening up. On the other hand, all too often his personal interests seemed to be closely intertwined with his

political decisions. For Castle Street to be completed it had to pass through land co-owned by Riddoch, which he refused to sell until the price was right.

Nethergate House was built for Riddoch at around the same time as other buildings in the vicinity also attributed to Samuel Bell – namely the Morgan Tower and Miln's Buildings at Nos 136–148 Nethergate. True to form, Provost Riddoch altered the line of Nethergate so that it passed in front of his new residence, giving an open, paved and well-lit approach to the front of his house that complemented the fine views to the river from the rear. The street had previously been situated to the north of the Morgan Tower. Indeed, it may be that the simple explanation for the unusual appearance of that building is that the bow fronted element that gives it its name was originally intended to be at the rear. (Miln's Buildings has similar rear-facing bows.) The addition of the Venetian windows and other elements can then be seen as an attempt to enhance what had become the street frontage.

Nethergate House itself is a simple but elegant structure with perhaps its most unusual feature being its curved windows. (Riddoch was a partner in a glass works at Carolina Port around the time the house was built.) For many years the building was occupied by the Clydesdale Bank.

Nethergate House. *Inset*: Nethergate House in the 1930s.

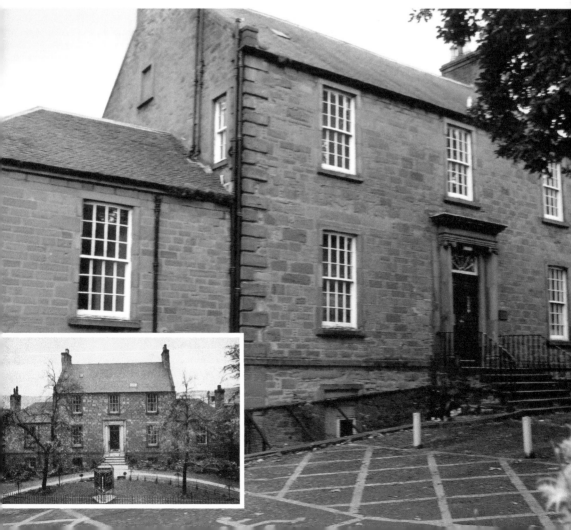

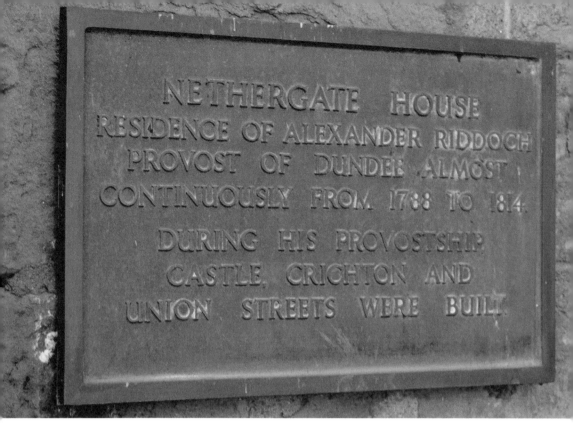

NETHERGATE HOUSE
RESIDENCE OF ALEXANDER RIDDOCH
PROVOST OF DUNDEE ALMOST
CONTINUOUSLY FROM 1788 TO 1814.
DURING HIS PROVOSTSHIP
CASTLE, CRICHTON AND
UNION STREETS WERE BUILT

Plaque commemorating Alexander Roddoch.

12. Camperdown House (1824)

The house on Lundie Estate had stood for more than a century by the time the lands were purchased by the Duncan family in 1682. It was demolished to make way for its successor in the 1820s. By this time, the estate had been renamed Camperdown to commemorate the victory of Admiral Adam Duncan over the Dutch at the Battle of Camperdown in 1797. Duncan had been created Baron Duncan of Lundie and Viscount Duncan of Camperdown in the wake of the battle and awarded a pension of £3,000 a year.

Admiral Duncan died in 1804 and the new Camperdown House was built by his son Robert, the 2nd Viscount (later Earl of Camperdown). It was designed by William Burn in a Greek Revival style. The two-storey building was constructed using stone from Cullaloe Quarry near Burntisland. The building has two main aspects – the portico with its six Ionic columns takes up the eastern façade while the main south façade allows open views over the grounds. The interior has a sequence of grand interconnecting rooms – a dining room, library and drawing room. The most magnificent room, though, is the double height central saloon with its scagliola pillars and domed roof.

Robert, the 3rd Earl, was the last member of the family to live at Camperdown House. The estate later passed to his brother and then to Georgina, Dowager Duchess of Buckinghamshire, who died in 1937. It was sold to the Dundee Corporation and officially opened as a public park by the then Princess (later Queen) Elizabeth in 1946.

Camperdown Country Park remains a popular public space in Dundee today and includes a golf course and wildlife centre. The park covers an area of over 400 acres and

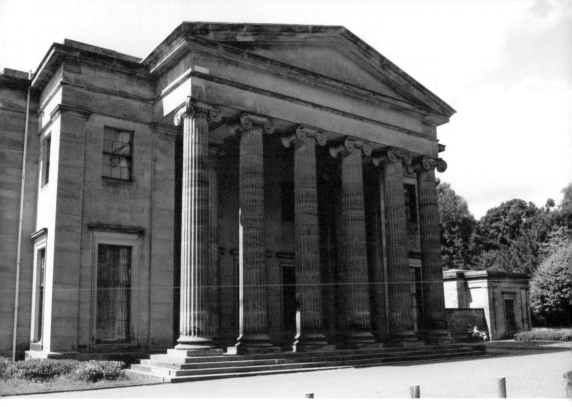

Above: Main entrance of Camperdown House.

Below: Camperdown House.

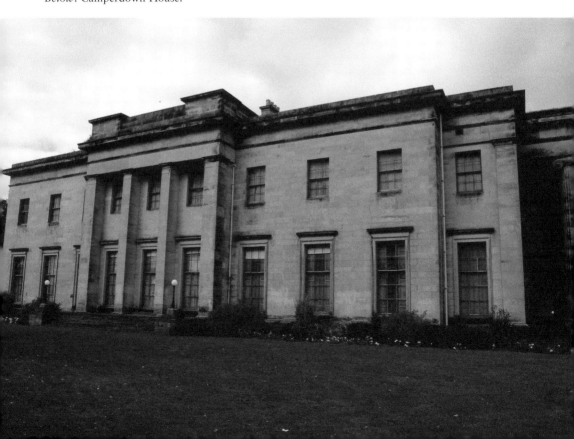

contains almost 200 species of trees, many of which were planted in the nineteenth century to the 2nd Earl's design. Camperdown House has largely been closed to the public in recent years, though part of the building acts as a clubhouse for the golf course. It is to be hoped that a use can be found that allows this magnificent building to be fully opened on a permanent basis.

13. Dens Works (1828)

The first member of the Baxter family to arrive in Dundee was a handloom weaver from Tealing in Angus named John Baxter, who came to town with the Revd John Glas around 1728. His descendants established themselves as successful textile merchants in the town and during the Napoleonic wars supplied sailcloth to the Royal Navy including Nelson's flagship, HMS *Victory*.

As the Industrial Revolution took hold, steam-powered mills began to appear in Dundee powered by local water sources such as the Scouring Burn and the Dens Burn. In the 1820s the Baxters built their first such mill in the Lower Dens area. This was the beginning of a complex of buildings which came to dominate the whole of this area at what was then Dundee's eastern boundary.

Lower Dens Mill.

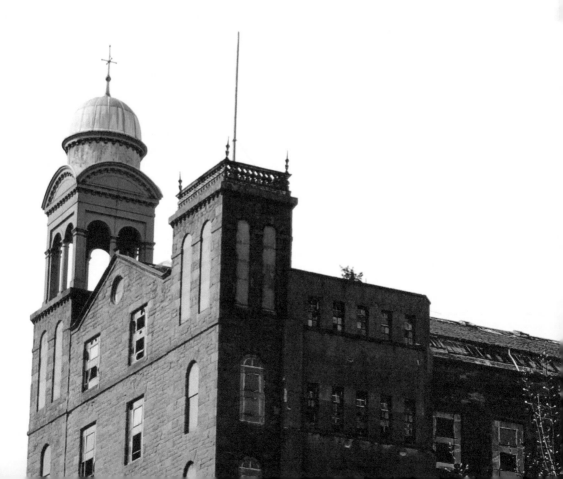

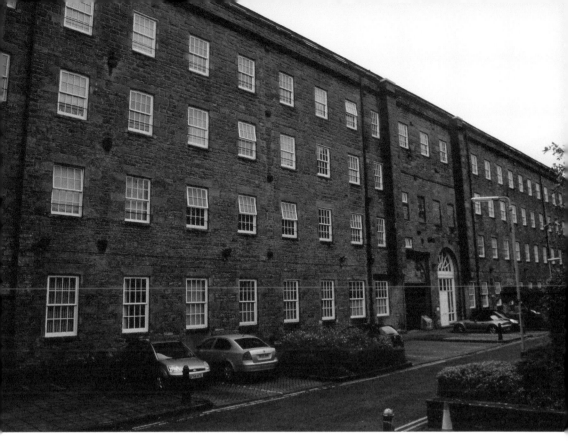

Upper Dens Mill.

In 1833, work began on an enormous mill in the Upper Dens area designed by Messrs Umpherston and Kerr. This mill was extended in 1850 and some of the buildings in the Lower Dens complex were replaced in 1865. The new buildings included the landmark five-storey Bell Mill, which has a tower based on the bell tower of the seventeenth-century Santa Maria della Salute Church in Venice.

By the mid-1860s, Baxters were Dundee's largest textile employer, boosted by the demand for their products occasioned by both the Crimean War in the 1850s and the American Civil War a decade later. At this time, they employed more people than even their nearest local rivals in the textile business, Cox Brothers of Lochee. It was only in this period too that Baxter began jute production.

Latterly part of the Low & Bonar group, production at Dens Works finally came to an end in 1978. The Upper Dens Mill was converted to housing in the 1980s, while much of the Lower Dens works slipped into dereliction. If the fact that one of the great centres of Dundee's industrial might have lain empty and vandalised seems to symbolise the city's decline, then it is surely to be hoped that its resurrection as a luxury hotel is representative of a bright future for the city.

14. Exchange Coffee House (1830)

The Exchange Coffee House was built between 1828 and 1830 to a design by the Aberdeen-born architect George Smith, a former assistant to William Burn, the man responsible for

the design of Camperdown House. The building was intended as a facility for Dundee's international merchants at a time when improvements to the docks helped to boost the town's importance as a port, providing them with a coffee house, meeting place, library and reading rooms. This was not the first building on the site – vaulted cellars with storm doors survive underneath the building pointing to a much older structure.

The neoclassical exterior and the open space in front gives the Exchange Coffee House an imposing appearance that was for many years obscured by Dundee's main bus stance. The interior retains many original features such as the grand staircase and sections of early murals. The most magnificent feature of the interior is the large first-floor reading room with its 30-foot-high coved ceiling and large windows which would once have afforded views of the busy dockside.

From around 1870 the reading room was used as the Dundee Music Hall before becoming the City Assembly Rooms in 1889, when it was announced that it would henceforth be used for 'balls and high class concerts'. In the early twentieth century the building was used as a Masonic Temple, but it is as the home of Dundee printers and publishers David Winter & Son for most of that century that many in the city will remember it. Today the upper floor is used as 'The Shore', a youth venue run by Dundee City Council.

In the building's early days, it was hoped that the ground floor would be home to a new Custom House but it was instead given over to shops. The shop on the north side of the main entrance, once occupied by Winter's, is now 'The Corner' – an advice centre for young people. The one on the south is a pub that once had the name 'Lennon's' until threatened with legal action by the widow of former Beatle John Lennon.

Old postcard view of the Exchange Coffee House and docks.

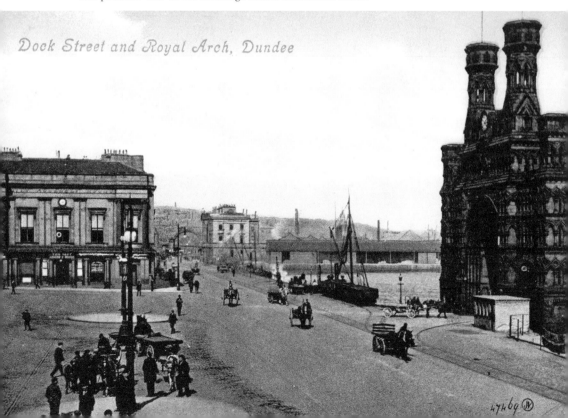

Dock Street and Royal Arch, Dundee

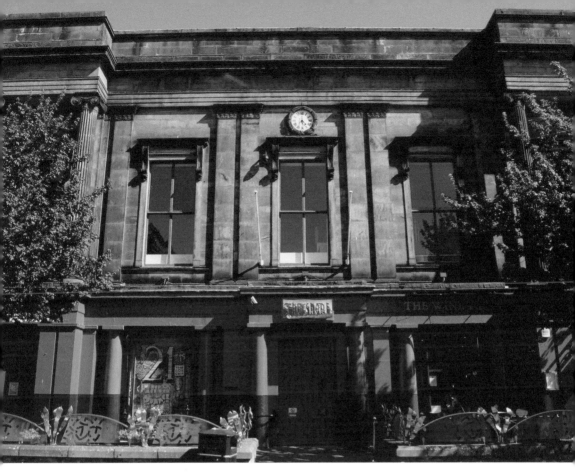

The Exchange Coffee House.

15. High School of Dundee (1834)

The history of the High School of Dundee long predates the building that currently houses it. The school can trace its origins back to the foundation of a grammar school for Dundee by the Abbot of Lindores Abbey in 1239 and can reputedly count William Wallace among its former pupils. For 200 years from 1589 the school was situated in St Clement's Lane before moving to a building in School Wynd that it shared with another school known as the English School, which had been founded in 1702. In 1829, it was decided that these two schools together with a third, Dundee Academy, which was then housed in the old hospital building in the Nethergate, should be brought together in one building to be known as the Dundee Public Seminaries.

The design of the building was the result of a competition which was won by George Angus, the architect responsible for the planning and appearance of nearby Reform Street. The street took its name from the Great Reform Act of 1832 and opened up a direct route from the town's High Street to the Meadows. The school was to provide an attractive terminal feature for the view down the new street.

Dundee Public Seminaries opened in October 1834, following the completion of the main building. The Doric pillars that dominate the front elevation are typical of the Greek style that Angus favoured for public buildings. Despite the single building, it took some time for the three schools to truly function as one. It was not until November 1859 that the

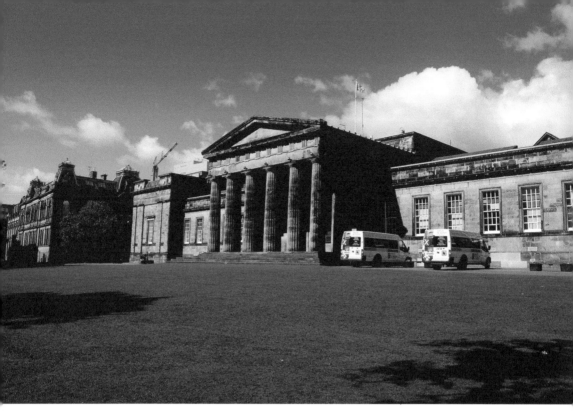

Above: The High School of Dundee.

Below: Margaret Harris Building.

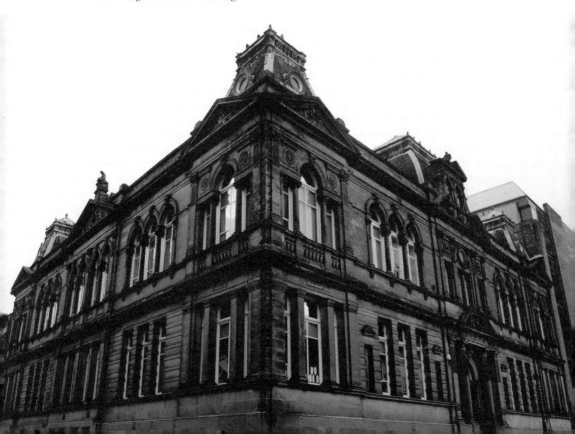

name High School of Dundee was adopted following a Charter of Incorporation granted by Queen Victoria.

The school buildings have been expanded and adapted many times over the years. In the 1850s the rear wings were extended. The Girls' School, now known as the Margaret Harris Building in Euclid Crescent, was opened in 1890. In the 1950s the main school's interior was remodelled and the dining hall added. Nearby buildings have been adapted to school use – most recently the former General Post Office (*see* entry 31).

16. The Vine, No. 43 Magdalen Yard Road (1836)

George Duncan was the Liberal Member of Parliament for Dundee between 1841 and 1857. In 1844 it was Duncan who presented the Provost and the other local dignitaries to Queen Victoria and Prince Albert when they landed at Dundee Harbour.

Before entering Parliament, Duncan had built up a fortune from a drapery and silk business from which he retired in 1836. In the same year he had The Vine, a single-storey neo-Greek pavilion-style villa built at Magdalen Green. The Vine sits in a large garden and is elevated to provide what would have been, at the time of its construction, uninterrupted views of the Tay. It was built not only as a home for Duncan but also to house his art collection. At the centre of the building is a large top-lit hall where paintings and other artworks could be displayed, with the other rooms leading off. Duncan died at The Vine in early 1878 and was the last person to be buried in Dundee's Howff graveyard.

The Vine.

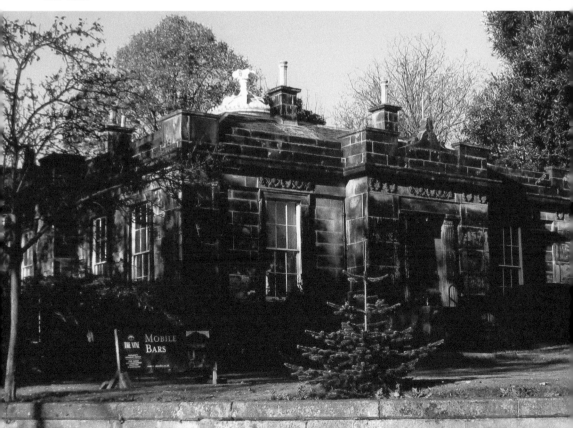

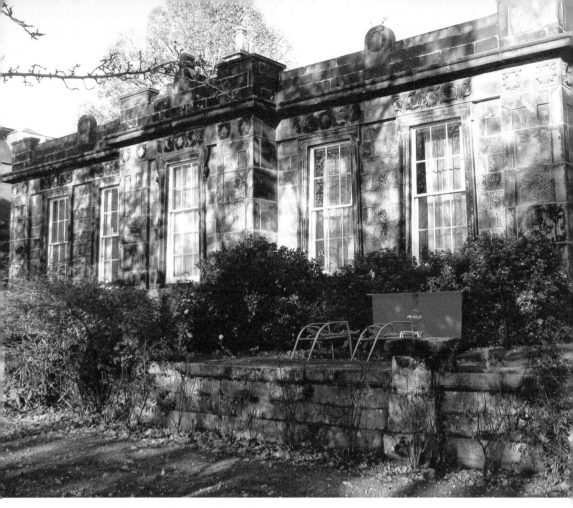

The Vine from Magdalen Yard Road.

The Vine then passed through several ownerships including the family of Dundee shipowner and later Lord Provost Charles Barrie and furniture designer George Fairweather, as well as the Ministry of Works. It is now a successful venue for events, meetings and functions.

17. Custom House (1843)

Until the early nineteenth century, Dundee's Custom House was situated in Pierson's Lodgings, a large building at the foot of present-day Crichton Street which dated from around the beginning of the seventeenth century. The lower floors of this building had been converted into shops while the Custom House was on the top floor. The rapid expansion of trade in Dundee by the 1830s meant that there was great demand for a new customs facility. This expansion is reflected in the fact that the three-storey Custom House that was eventually built was the second largest such building in Scotland after the one at Greenock.

The new Custom House was a collaboration between the architect John Taylor and James Leslie, who was Resident Engineer for the Dundee Harbour Works. Leslie had

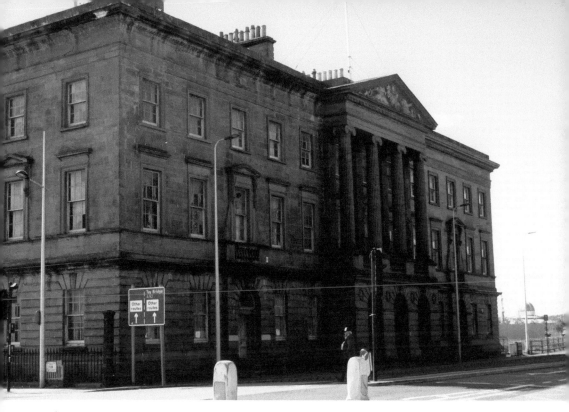

Above: Custom House.

Below: Entrance to Harbour Chambers.

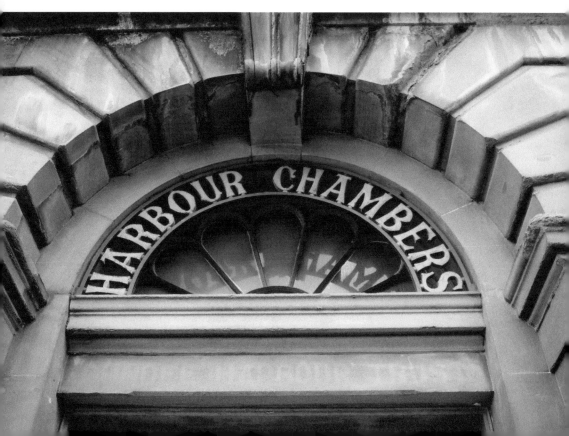

overseen the improvement of Dundee's harbour facilities and the creation of the Earl Grey, Camperdown and Victoria Docks, which were now linked by the aptly named Dock Street, where the building was to be situated.

Although commonly referred to as the Custom House, the eastern side of the building contained the Harbour Chambers, which provided accommodation for the Harbour Trustees and officials. It was James Leslie who was responsible for the greater part of the building's design while Taylor was chiefly responsible for the Greek-style façade, with its projected portico with Ionic columns running through two floors, topped with a pediment enclosing the Royal Coat of Arms.

Despite its grandeur, the Custom House building is easily missed given its setting by a busy road. It lacks the open space in front to show it to its best effect that its erstwhile rival at Greenock has (some would argue that the Greenock Custom House gains simply by having been built facing the water). Nevertheless, as redevelopment turns Dundee's attention back to the waterfront, the former Custom House is set to be converted into a luxury hotel. In an area which is looking so keenly to the future, it is perhaps important that such a magnificent building is preserved to show that Dundee's waterfront also has a fascinating past.

18. Camperdown Works (1850)

The Cox family had a pivotal role in the development of Lochee since James Cock (the spelling was later changed to Cox) set up business as a linen manufacturer in the area around 1700. By the middle of the nineteenth century, the business had been passed down to four brothers, James, William, Thomas and George Cox, and had switched to jute manufacture. In 1850, they opened Camperdown Works at Harefield, Lochee.

Occupying 30 acres, the works in its prime had its own branch railway, fire station, stables, foundry and half-time school, and employed around 5,000 people. The largest building was the High or Silver Mill, which was some 70 feet in height and 500 feet in length with a clock tower at one end. The clock became a well-known landmark in the area but was overshadowed by its near neighbour, the works' great chimney – known locally as Cox's Stack. Built at a cost of £6,000, Cox's Stack is 282 feet high and said to contain around a million bricks. Its appearance is based on an Italian campanile or bell tower and the exterior is composed of intricately patterned coloured brickwork.

The decline of the jute industry in Dundee was as long and drawn-out as its growth had been rapid. While it still employed thousands of people for much of the twentieth century, growing competition from the Indian subcontinent meant that its days were numbered. Cox Brothers Ltd became part of Jute Industries Ltd in 1921 and Camperdown Works finally closed in 1981.

Nevertheless, the influence of the Cox family remains strong in Lochee. They donated the local library, park and swimming baths, while the housing developments at Beechwood, Foggylea and Clement Park echo the names of their mansions. Indeed, many local families owe their presence in the area to an ancestor who came to work for the Coxes.

Most of Camperdown Works has been demolished and the site is largely occupied by retail units. The High Mill has been converted to housing but Cox's Stack still dominates the skyline, standing as a monument to Dundee's industrial past.

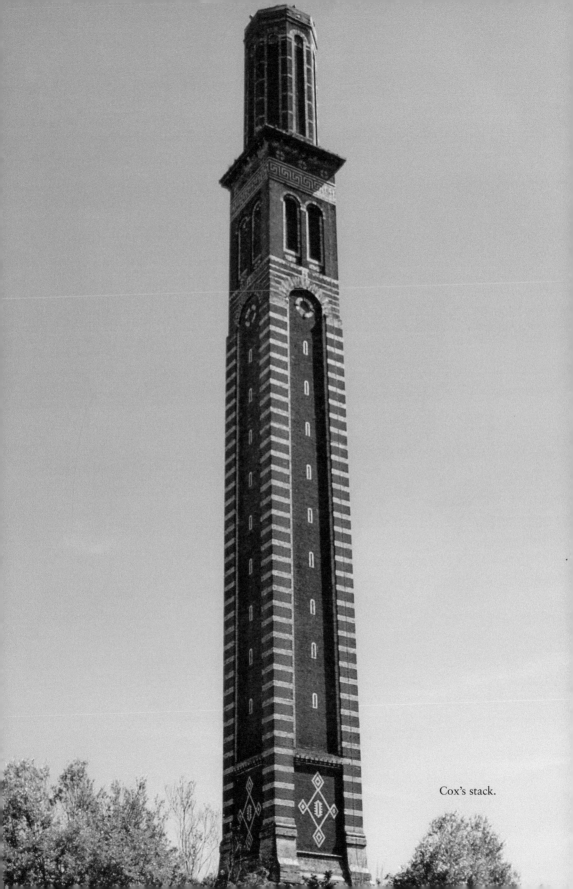

Cox's stack.

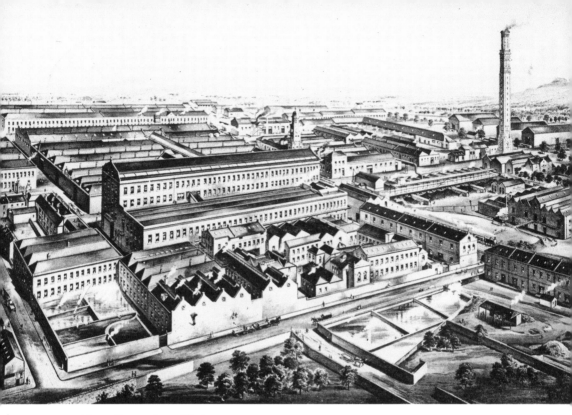

Above: Camperdown Works.

Below: The High Mill.

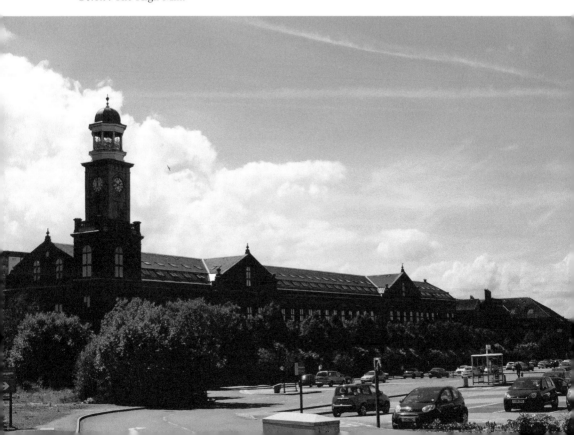

19. St Paul's Cathedral (1855)

At the ceremony to lay the foundation stone of St Paul's Cathedral in 1853, Bishop Alexander Penrose Forbes talked of how far the Episcopal Church had come in the preceding century. 'In 1753', he said, 'we were but a scattered remnant, with a penal law forbidding our ordinances ... our clergy could scarcely minister to their scanty flocks. Now ... we stand here a free people.' The denomination was certainly expanding in mid-nineteenth-century Dundee, leading to the need for larger premises. The remnants of the façade of the previous St Paul's chapel with its bricked-up gothic windows can still be seen in Castle Street today.

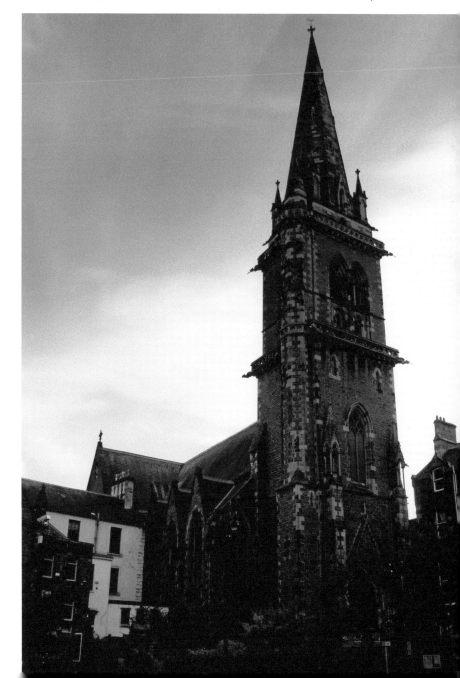

The first
St Paul's
Cathedral.

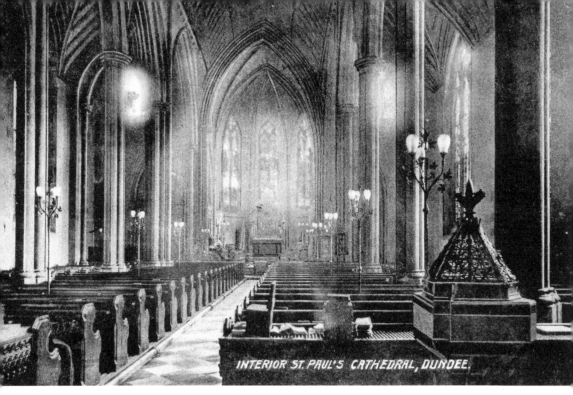

Interior of St Paul's Cathedral.

The new St Paul's was opened in December 1855 and raised to Cathedral status some fifty years later. It was built on the remnants of the rock on which the medieval castle of Dundee had once stood. The castle is thought to have been destroyed by the Scots to prevent its capture by the English in 1313. The elevated site, which is approached by a daunting three flights of steps, only serves to emphasize the height of the 210-feet spire and the grandeur of Sir George Gilbert Scott's Gothic Revival building as a whole.

The lofty setting, however, means that the full extent of the building and indeed its cruciform structure is not really appreciated from ground level. The interior remains impressive today with its magnificent stained-glass windows, which were mainly the work of one of the leading manufacturers of stained glass of the day Messrs Hardman and Co. of Birmingham, but with a further one each by Scott and Draper of Carlisle and Gibbs of London.

Other notable features of the interior are the Lady Altar, which was taken from the Castle Street chapel; the mosaic reredos at the High Altar designed by Antonio Salviati of Venice; and the baptismal font, part of which is from Lindores Abbey. Also in the church is the tomb of Bishop Forbes himself but it is surely St Paul's Cathedral, still the mother church of the Diocese of Brechin in the Scottish Episcopal Church that is his true monument.

20. Dundee Royal Infirmary (1855)

Hospital facilities in medieval Dundee such as that at the Nethergate had been attached to monastic institutions. It was not until the eighteenth century that the town, in common with others such as Edinburgh and Glasgow, gained a hospital in the modern sense.

In 1782, a dispensary was opened for the distribution of advice and medicine to the sick poor. Following the success of this institution, a committee was formed to raise funds for a hospital and when this was built in King Street in 1798 its function was combined with that of the dispensary. The King Street building was later expanded but it was soon realised that it would still be inadequate and plans were made for a new facility.

A 10-acre site was chosen on the lower slopes of the Law between Dudhope Castle and the Dundee and Newtyle railway line. The competition-winning design was by the architects Coe & Goodwin of London and was in a Tudor style with an impressive central gatehouse with octagonal towers and an oriel window. The foundation stone was laid on 22 July 1852 and the building opened three years later with accommodation for 220 patients. Styled Dundee Royal Infirmary by virtue of a Royal Charter, the hospital was one of the first to separate medical, surgical and fever wards.

Many alterations were made to the infirmary over the years. The building originally had dressings in Caen stone (a creamy-yellow limestone) but these were replaced in 1869. Various other buildings were added to the site in the course of the next century, during which time it was Dundee's main hospital.

From the opening of Ninewells Hospital in 1974, however, many of the Infirmary's functions began to be removed there. The old hospital finally closed its doors in 1998, some 200 years after its foundation. The Infirmary buildings have since been converted into housing. Its medical history, though, is remembered at Ninewells in the shape of the DRI Memorial Wall, which features many of the commemorative plaques that were sited at the Infirmary along with photographs and other memorabilia.

Dundee Royal Infirmary.

The former Caird Building, Dundee Royal Infirmary.

21. The Royal Exchange (1856)

By 1850, Dundee's Chamber of Commerce had outgrown the meeting place that they had rented from the Dundee Union Bank for the preceding fifteen years – the Baltic Coffee House at Bain Square between the Wellgate and the Cowgate – and decided to move to purpose-built accommodation on the edge of the town's meadows. Despite its picturesque name, 'the meadows' consisted of around an acre and a half of boggy ground caused by the confluence of several water sources in the area.

The Edinburgh architect David Bryce won the competition to design the building with his striking vision in the style of a fifteenth-century Flemish-Gothic Cloth Hall. As was the case with such buildings there were many ornate details, including intricate decorative stonework on the dormer windows and large gargoyles projecting out from the square tower at the east end. In Bryce's original plans, the tower had been intended to have a two-tier decorative extension capped by a crown spire. As work began, however, it became clear that due to the subsidence caused by the boggy ground, plans for the crown spire would have to be abandoned. The struggle against the terrain meant that work took longer than expected and the building was finally opened with an inaugural festival on 1 April 1856 – two days after the end of the Crimean War.

The interior of the building was designed to meet the needs of the members. While the street level housed various offices and other rooms, the first floor was largely given over to

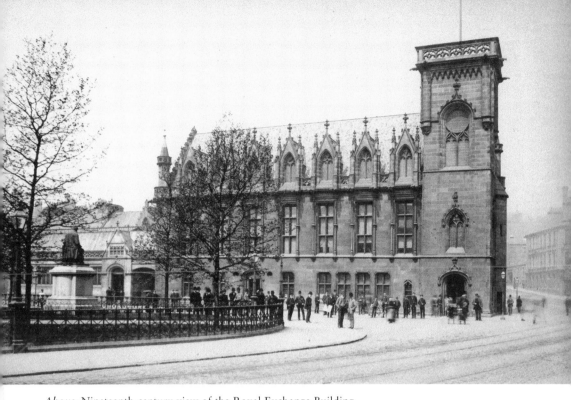

Above: Nineteenth-century view of the Royal Exchange Building.

Below: Royal Exchange Building in the twenty-first century.

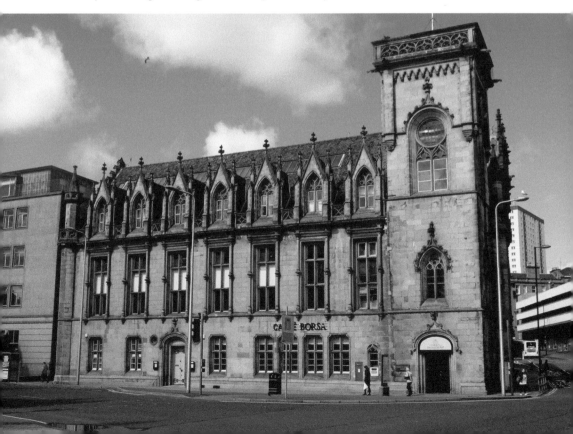

a Reading Room. This imposing space featured a double hammer-beamed roof and several fine stained-glass windows.

Today the building is used for various purposes. The ground floor houses a pub while the former Reading Room is used for functions. The stained-glass windows remain as a reminder of the building's past but the hammer-beamed roof is no longer visible from the former reading room. Alterations in 1954 created an additional floor which is now home to the Fleet Collective, who provide studio space for people to work both collaboratively and individually on creative projects.

22. Lochee Station (1861)

The Dundee and Newtyle Railway opened in 1831. Thirty years later, a deviation was constructed which brought the line to Lochee, thus avoiding the steep incline that took it through the Law tunnel. Three new stations were opened on this section of line: Lochee, Lochee West and Liff. Of these, only the first survives.

The building is the work of the architect James Gowans and is in his own unique modular style based on 2-foot sections of multicoloured rubble. Gowans was also a quarry owner, which may explain his unusual use of stone in this building. He had employed a similar technique on his own house, Rockville, in Napier Road, Edinburgh two years earlier. Rockville was demolished in 1966 but a smaller house, Lammerburn, survives nearby. This,

The former Lochee railway station building.

together with Lochee station and the rebuilt and converted Creetown railway station in Kirkcudbright, are the only surviving examples of this style of building by Gowans.

After the closure of the railway, the Lochee station building was converted for use as a social club by the Lochee Burns Club, with the addition of an extension on the former platform side. It remains a rare survivor among Dundee's historic railway station buildings.

23. Sheriff Court (1863)

Bell Street has been synonymous with the dispensation of justice in Dundee for more than a century and a half, having housed not only the Sheriff Court Building but the central police station and the town's prison, as well as having been the site of executions.

The plans for the Dundee Sheriff Court complex were first drawn up by George Angus in 1833 but only the east pavilion on West Bell Street containing the police station and the prison were built around this time. The courthouse itself was not completed until 1863. William Scott, who was by then the town's architect, adapted Angus's original plans. In common with Angus's design for the High School, the building is in a classical style, dominated by its Roman Doric portico.

The prison closed its doors in 1927 and it was demolished soon after this date. The governor's house and the western pavilion survived much longer but have both since been demolished, removing the symmetry of the original design. The police headquarters moved to the site of the former prison in the mid-1970s. Twenty years later, the court buildings were refurbished and sympathetically extended by the Dundee firm Nicoll Russell Studios.

The now demolished western pavilion, seen here in the 1970s.

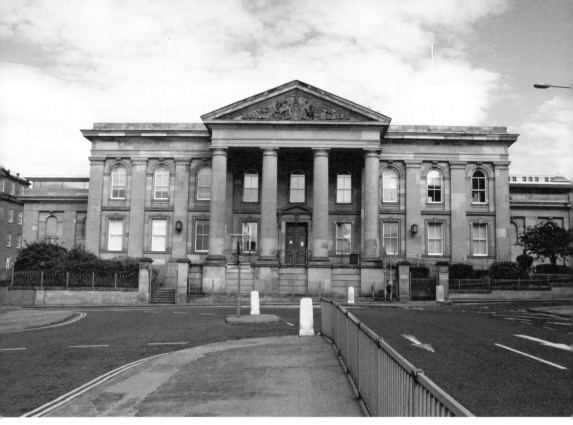

Dundee Sheriff Court.

24. Immaculate Conception Church, Lochee (1866)

The hunger and desperation that followed the failure of successive potato crops in Ireland in the late 1840s led many to leave home to seek work elsewhere. Dundee's booming jute industry made it an attractive destination for the Irish and many came to Lochee in particular, drawn by Cox's Camperdown Works. At one time so many Irish families had settled in the area around Albert Street (later Atholl Street) in Lochee that it earned the nickname Tipperary.

The vast majority of these immigrants were Roman Catholics but there were no religious or educational facilities for them in the area. To remedy this the Catholic Church purchased a building known as the Walton for use as a school, while its coach house was converted into a chapel. The Catholic population of the area soon outgrew this, however, and it was clear that a new church would be required. The Walton, later known as Wellburn, was transferred to the Little Sisters of the Poor.

The new church was completed in 1866 and was designed by Joseph Aloysius Hansom, a York architect and the man who both invented the Hansom Cab and founded *The Builder* magazine. Its most outstanding feature, both inside and out, is the multi-sided chancel which focuses light, and therefore attention, on the sanctuary after the relative darkness of the nave.

Some distinctive features of the interior today were not in place until the later years of the nineteenth century. The magnificent stained-glass windows were made by Mayer of Munich. The central image depicts the nativity scene and is flanked on either side by two images of saints. On one side are Saints Francis and Peter (in memory of two early parish

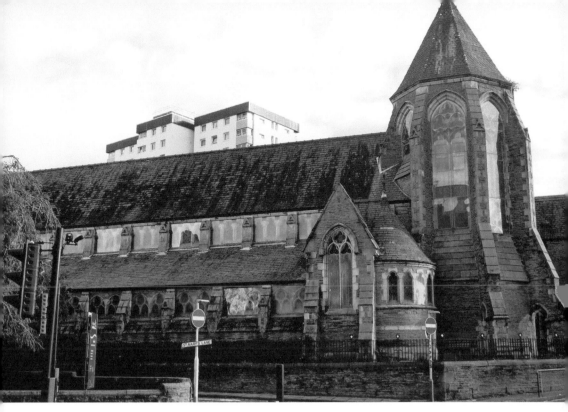

Above: Immaculate Conception Church from Lochee High Street.

Below: Immaculate Conception Church from St Mary's Lane.

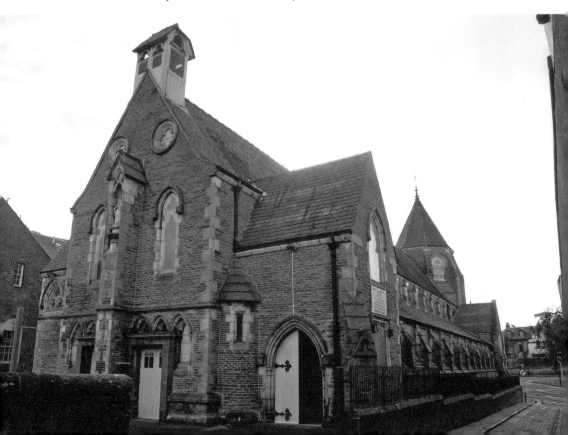

priests who bore those names) and on the other are Saints Patrick and Bridget, Ireland's patron saints. The altar piece is by Messr A. B. Wall of Cheltenham. The similar Lady Altar was not installed until 1900.

The church, better known to most as St Mary's, Lochee, is still an active place of worship today and celebrated its 150th anniversary in 2016.

25. The Albert Institute (1867)

When Queen Victoria's consort Prince Albert died in 1861, many different monuments to him were erected around the country. In Dundee, a group of prominent citizens including Sir David Baxter and Bishop Forbes proposed that an institute to promote literature, science and art bearing the prince's name should be built on the town's meadow ground. The meadows at the time were home to various unsightly temporary structures such as sheds and fruit stalls, and a great public building there would undoubtedly improve the appearance of the area. As we have seen, however, the boggy ground was particularly unsuitable for building.

The architect for the institute was George Gilbert Scott who had designed St Paul's Cathedral in Dundee and would later be responsible for the Albert Memorial in London. His design was in the Gothic style for which he was famous. The nature of the ground meant that £10,000 had to be spent on timber piles before work could even begin. A planned central tower with a spiral staircase had to be abandoned, giving rise instead to the famous exterior circular staircase.

The Albert Institute (now McManus Galleries).

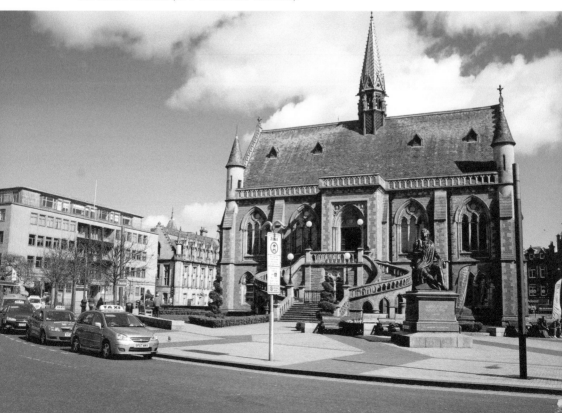

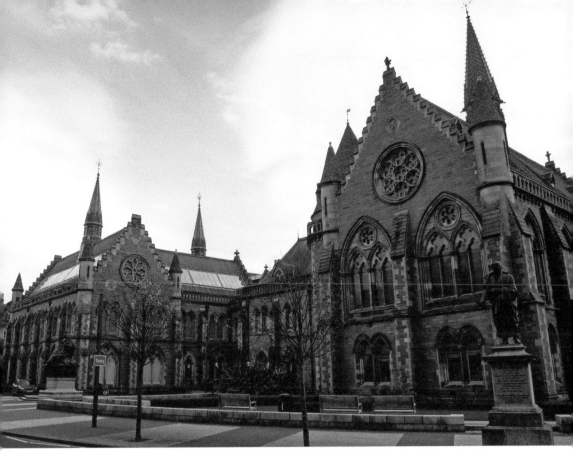

North side of the McManus Galleries.

The building opened in 1867, with a public library opening on the ground floor in 1869. The upstairs was given over to a Great Hall for public lectures and events. There were extensions built between 1871 and 1873, and 1887 and 1889, designed by David Mackenzie and William Alexander, both of whom attempted to stay true to Scott's original design. The Great Hall was eventually given over to the expanding library while the rest of the building housed an art gallery and museum. With the construction of the Wellgate Centre in the 1970s, the Central Library was given a new home, leaving the Museum and Art Gallery with room to expand. Around this time, the Albert Institute was renamed the McManus Galleries after former Lord Provost Maurice McManus.

In the early twenty-first century there was a major refurbishment by Page Park architects, which has stood the building in good stead, enabling it to celebrate its 150th anniversary in 2017 while remaining as one of Dundee's top attractions.

26. Morgan Academy (1868)

John Morgan was a Dundee merchant who had made his money in India. Following his death in 1850, he left part of his fortune for the establishment of an institution for the support and education of poor children based on Heriot's Hospital in Edinburgh. A lengthy legal wrangle regarding this bequest, which went all the way to the House of Lords, however, meant that it was to be some years before Morgan's vision was realised.

The Morgan Hospital finally opened its doors in February 1868. Situated on a triangular piece of land between Forfar and Pitkerro Roads, the building by architects Peddie & Kinnear exhibits a style that is influenced by both French chateaux and Flemish Gothic halls. Its appearance has often been compared to that of Edinburgh's Fettes College, designed by David Bryce around the same time.

In the early days the institution educated boys only, all of whom were boarders. In 1889, however, the school was acquired by the Dundee School Board and renamed Morgan Academy, becoming a fee-paying day school providing both primary and secondary education. Alterations were made to the building at this time, principally the roofing and flooring of the school's courtyard to form an assembly hall. Further modifications were made in 1913–1915 when three-storey rear blocks were added to the north side and again in the early 1990s, when another large extension was completed. It is not just the building's physical appearance that has changed over the years. It is now a co-educational and comprehensive secondary school, with the last primary intake being in 1955.

On 21 March 2001, a devastating fire ripped through the school. The windy conditions that evening meant that much of the main building was destroyed within hours. When the central tower collapsed at around 8 p.m., despite the valiant efforts of the fire brigade, many feared that the A-listed structure would not be saved. The school reopened in August 2004, however, after a three-year sojourn at the former Rockwell High School for the pupils. The fully restored familiar exterior now conceals a modern twenty-first century school.

Early twentieth-century view of Morgan Academy.

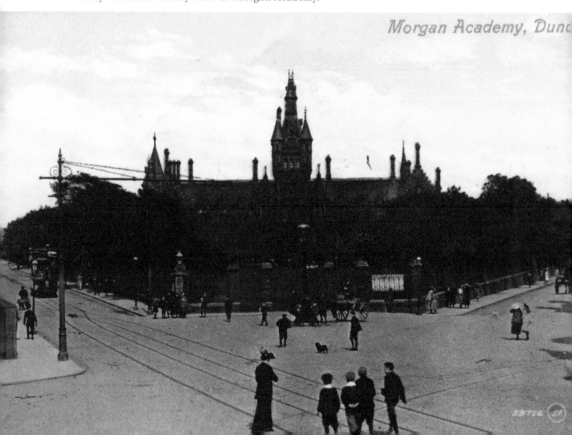

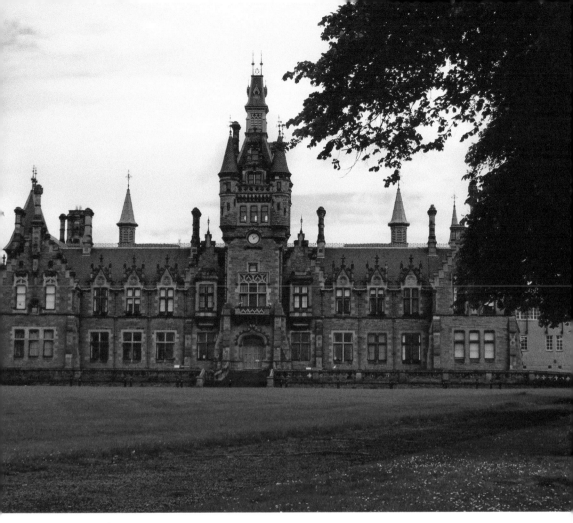

Morgan Academy.

27. St Salvador's Church (1868)

St Salvador's Church is the result of a mission to the Hilltown area launched in 1855 by Bishop Forbes and Revd James Nicholson of the Episcopal Church. Building on the site at Maxwelltown was undertaken in stages from 1858 to 1874. The first structure to be erected was the building that today is the Maxwell Centre but which originally comprised a school with a temporary church above.

The church itself was built in two stages, with the nave being constructed in 1867–68 and the chancel and Lady Altar in 1874. The design was by George Frederick Bodley, a one-time pupil of Sir George Gilbert Scott who rose to become one of the most important ecclesiastical architects of the Victorian era in his own right.

St Salvador's Gothic exterior with its steep slate roofs is well proportioned but is relatively simple and perhaps suffers from being hemmed in on two sides by the neighbouring buildings. If the exterior alone does not earn the church its place in this book, however, then the merest glance at the magnificent interior will show how it could not be omitted.

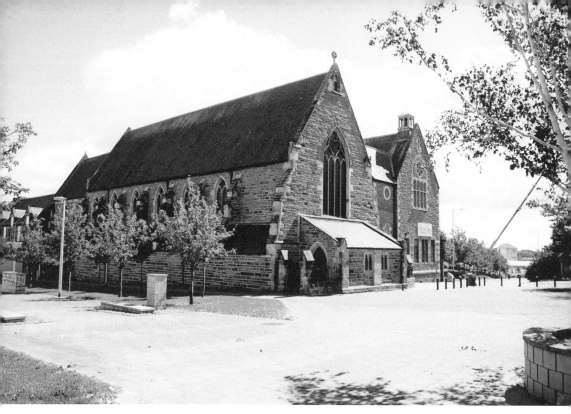

Above: St Salvador's Church.

Below: The nave of St Salvador's Church.

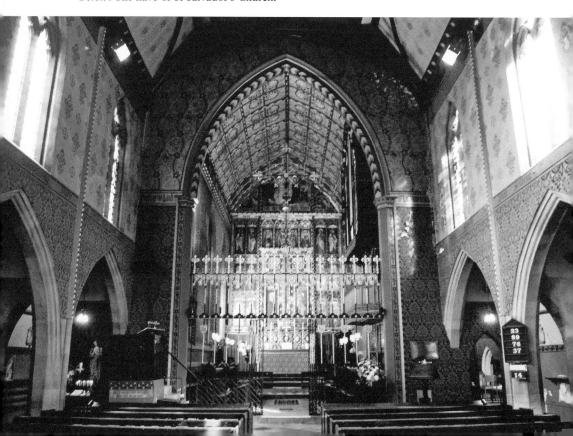

The reredos of St Salvador's Church.

The walls and ceiling are decorated throughout with stencil painting designed by Bodley. Originally in watercolour, this was replaced in oil paint in 1936 and restored in 1972. The painted and gilded iron chancel screen was also designed by Bodley, as was the beautifully painted panelled reredos which fills the whole of the east wall and depicts the crucified Christ with the Virgin Mary and St John at the foot of the Cross. Other panels show the Apostles and the Archangels. Above is a fresco of the Annunciation.

The stained-glass windows show various saints and are the work of the renowned English firm of Burlison and Grylls, except for that in the rose window in the west gable of the Lady Chapel, which was transferred from the similar window in the temporary church next door.

St Salvador's remains an active place of worship in the Episcopal Church today and is truly a hidden gem among the buildings of Dundee.

28. Faces Land (1871)

Given that for a large part of the nineteenth and twentieth centuries tenements were the standard type of dwelling for working-class Dundonians, it would seem remiss if at least one tenement building were not included in this list. Many of these buildings, though, were purely functional and unremarkable and so it is difficult to pick one that stands out.

'Faces Land', North Ellen Street.

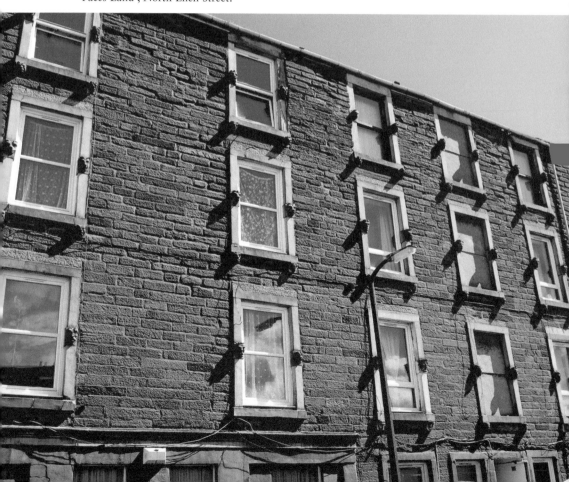

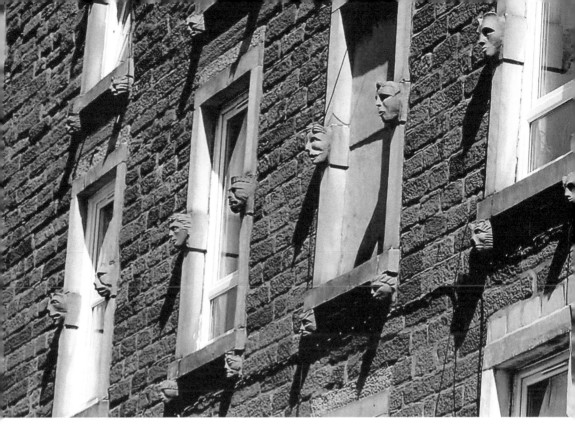

Above: Close-up of some of the 'faces'.

Below: The remaining 'face' at Ann Street.

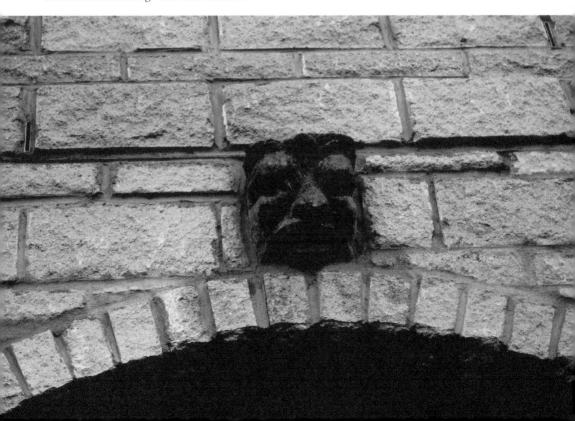

The tenement at nos 11–19 North Ellen Street, however, has something unusual about it that is obvious to the passer-by who takes the time to look up.

The window surrounds of the four-storey tenement designed by John Bruce in 1871 are decorated with grotesque animal and human heads. The block has long been nicknamed 'Faces Land' because of these unusual features. Each of the faces is different from the others.

As well as a nickname, the faces have earned the block the status of a category B listed building. The neighbouring block between 'Faces Land' and Alexander Street was also part of the development but does not share this status. Bruce was also responsible for a similar block at nos 3–9 Ann Street. This has been demolished but one of the faces has been incorporated into the replacement building.

29. Clydesdale Bank (1876)

Built in 1776, the Trades Hall occupied the site at the east end of Dundee's High Street that had once been the town's shambles (where animals were slaughtered). A century later, in the wake of the 1871 City Improvement Act, the Samuel Bell-designed building was removed, allowing the widening of the surrounding streets. The replacement building was to be set further back from the old market place and was on a smaller scale than its predecessor.

The Clydesdale Bank building was designed by William Spence and was built in 1876. The Lanark sculptor James Charles Young was responsible for the statues of Commerce and Justice that occupy the niches on either side of the main entrance, and the one of Britannia which stands guard on the roof. As the pictures show, the building has lost much of its fine detailed stonework over the years.

The building includes shop units in Commercial Street and offices above. In recent years, changes in banking habits have seen a great reduction in the number of branches and, no longer used as a bank, the Clydesdale Bank building now provides a somewhat grandiose setting for an optician.

Nineteenth-century drawing of the Clydesdale Bank Building.

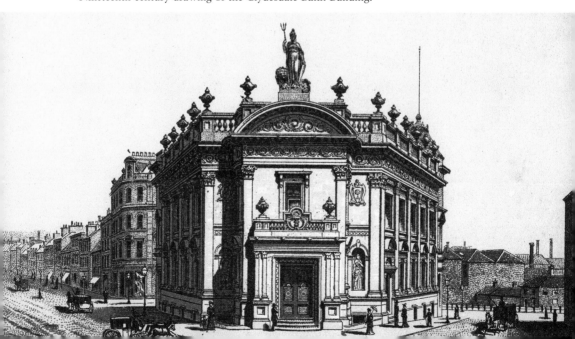

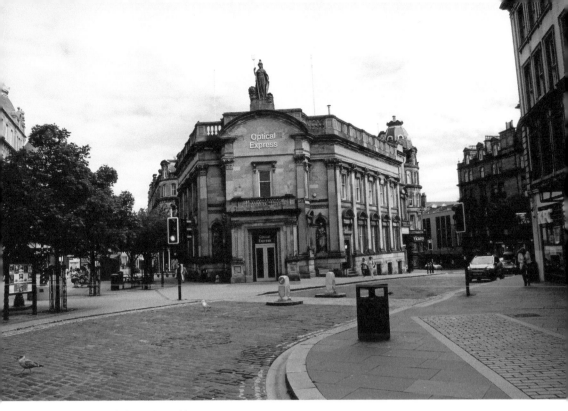

Former Clydesdale Bank Building.

30. Queen's Hotel (1878)

One of the first things that a weary traveller is likely to look for on arrival in a city is accommodation and so it is not surprising that so many railway stations have hotels associated with them. The Balmoral – formerly the North British – in Edinburgh's Princes Street, for example, towers over Waverley station.

On hearing that the Caledonian Railway Company was to build a new station at Seabraes in Dundee, local wine merchant Colonel William Smith commissioned a firm of architects, Young & Meldrum, to build a 'station hotel' in the Nethergate.

On Smith's instructions, John Young and Andrew Meldrum toured the country looking for ideas and inspiration. The finished hotel certainly had 'all mod cons' as a report written at the time of its opening in July 1878 points out:

> The heating apparatus maintains the atmosphere in a uniform air, the vitiated air being subject to a continuous discharge by means of an elaborate system of ventilators … Hot and cold water pipes are carried through the whole house … The lift is worked by hydraulic power, provided at a cost of between £300 and £400.

Unfortunately for Smith and his associates, however, when the station was finally built it was situated much further east at South Union Street. Nevertheless, the hotel proved successful in the long term, perhaps, ironically, because of its location outwith, but convenient for, the city centre.

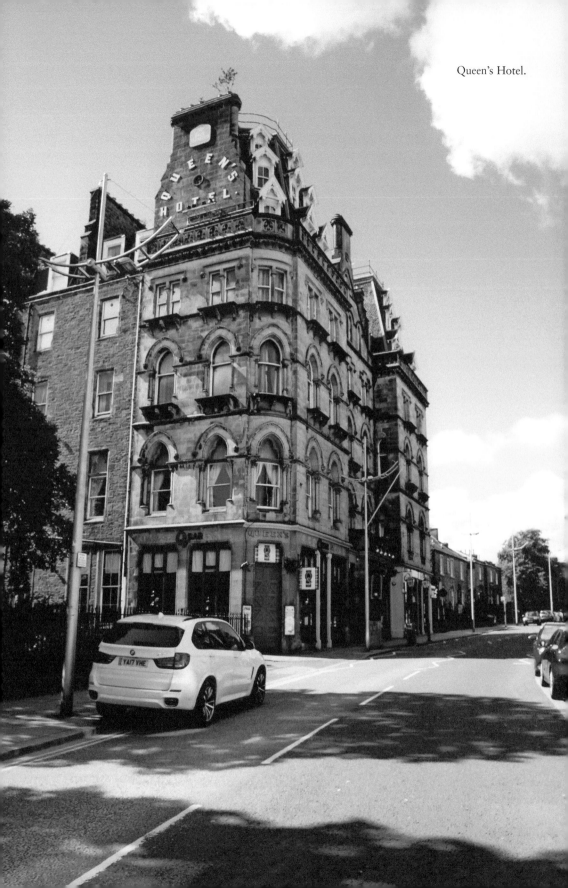

Queen's Hotel.

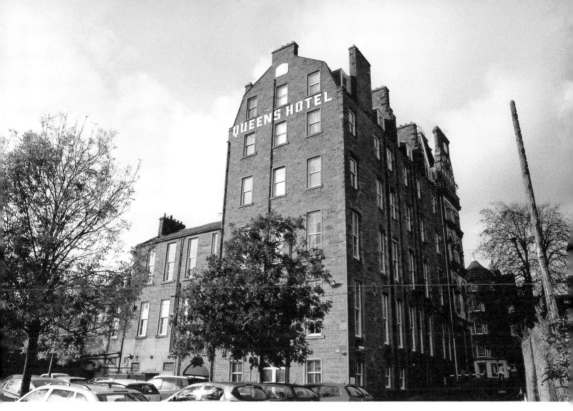

Above: Rear view of Queen's Hotel.

Below: Queen's Hotel: main entrance.

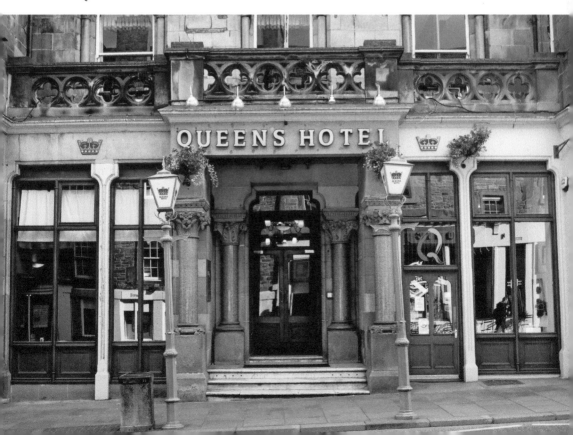

One famous guest, though, was less than impressed with the Queen's; 'This hotel is a great trial to me,' he wrote in a letter to his wife in 1908. The guest's annoyance was perhaps understandable; Winston Churchill had found a maggot in the kipper he had for breakfast that morning. Needless to say, standards have improved at the Queens since then and it remains a popular venue with Dundonians and visitors today.

One particularly interesting feature is to be found on the lower ground floor Victorian suite in the shape of a specially commissioned mural by local artist Ken Bushe, inspired by city architect James Thomson's 1910 architectural plans for Dundee's waterfront area.

31. General Post Office (1898)

Dundee's main post office was once situated on the site presently occupied by the Courier Building (*see* entry 33). Between 1895 and 1898, a replacement was built further along Meadowside to a design by the Office of Works architect Walter Wood Robertson, who was also responsible for designing or adapting many of the main post offices in Scotland's other towns and cities.

The building is in the Franco-Italian Renaissance style and has numerous adornments on its Meadowside and Constitution Road sides, including two angels above the main entrance. One of these angels carries a letter and once held a horn of the type used to signal the arrival or departure of a mail coach, while the other carries a thunderbolt as a symbol of the electric telegraph. A considerably less fussy red sandstone extension was added in Euclid Street between 1921 and 1922.

Former GPO building.

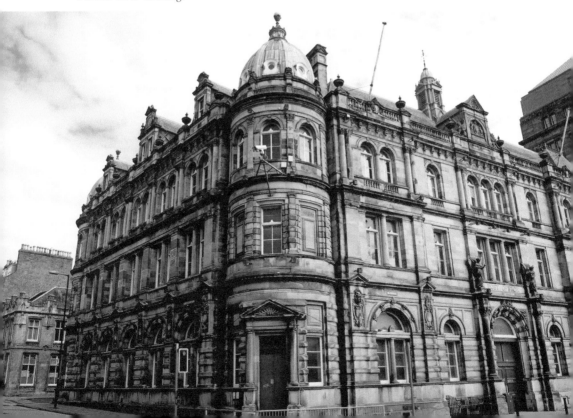

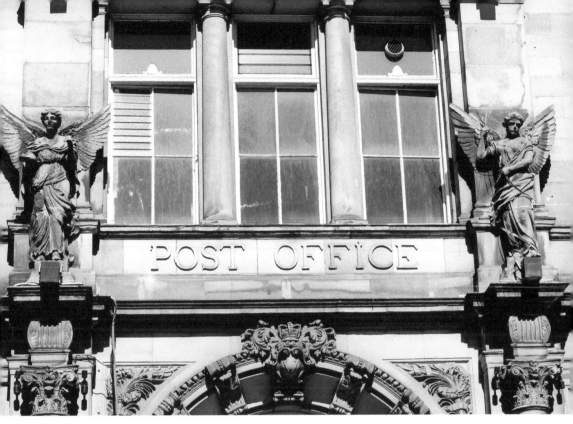

Close-up of sculptures on the GPO.

When the post office vacated the building for the modern premises next door, it spent some time as a nightclub before lying empty. In 2013, it was acquired by the High School of Dundee for conversion into a Centre for Excellence in Performing and Visual Arts under the supervision of the renowned firm of Page\Park Architects.

32. Mathers Temperance Hotel (1899)

The Mathers family opened their first temperance hotel in the Murraygate in the early 1860s. The venture was so successful that in 1870 they moved to larger premises at Crichton Street and later expanded into the newly opened Whitehall Street. As the new century approached, however, a fresh plot was purchased for an even more ambitious project.

Civil engineer and architect Robert Hunter was responsible for designing the hotel building, which is five storeys plus an attic high and extends from the western side of the Gilfillan Memorial Church in Whitehall Crescent round to the equivalent position in Dock Street. Its façade was designed to co-ordinate with those that city engineer William Mackison had approved for the neighbouring streets and while it blends in successfully, it is still allowed its own moment of glory in the shape of the landmark western elevation housing the main entrance.

In 1969, the building was sold to the Centre Group and renamed the Tay Centre Hotel. When it was sold on again it became known simply as the Tay Hotel. As the building approached its centenary, however, its story became one of sad decline. In 1992 it was

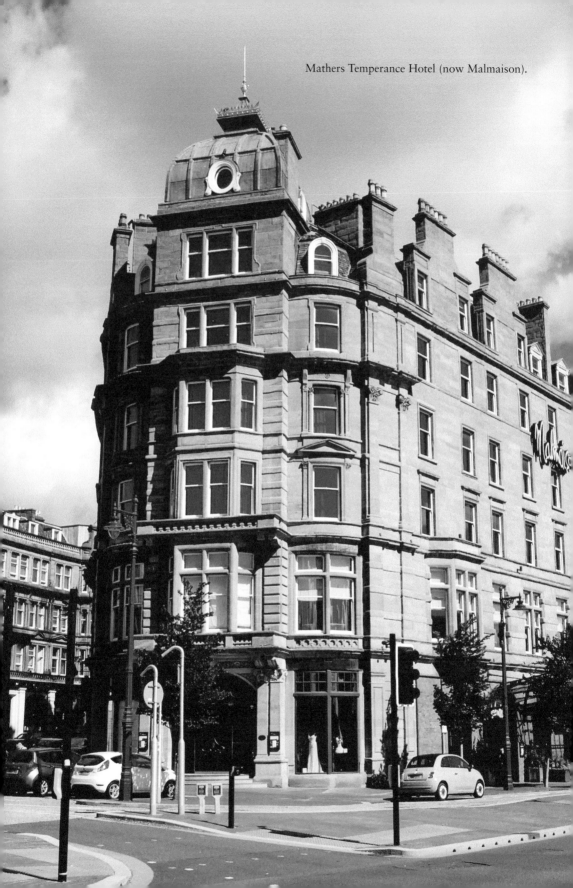

Mathers Temperance Hotel (now Malmaison).

damaged by fire and closed as a hotel the following year, closing entirely in the early years of the new millennium. The landmark building threatened to become just another eyesore in Dundee's neglected waterfront area.

It remained empty until boutique hotel chain Malmaison announced their decision to lease the building in 2011. The refurbished hotel has ninety rooms and suites, two bars, a lounge area, ballroom and a restaurant, and is ideally placed for the new waterfront development.

Margaret Mathers, who had been instrumental in her family's first venture into the hotel business, died in 1917, having lived to the age of 90. While she would no doubt be shocked that alcohol was so readily available on the premises, she would surely be proud to know that 100 years after her death the hotel that she helped to create was once again operating and occupying an important place in plans for Dundee's future.

33. The Courier Building (1902)

If there is one building that represents the third 'J' in Dundee's traditional industries of 'Jute, Jam and Journalism' it is surely D. C. Thomson's Courier Building at Meadowside. Built at the beginning of the twentieth century, the home of numerous publications including *The Beano* and *The Dandy* seems itself to have more in common with the backdrops to the American superhero comics of the 1930s than other Dundee architecture.

The building is actually the work of a London firm of architects, Niven & Wigglesworth. Both partners of the firm, David Barclay Niven and his brother-in-law Herbert Hardy Wigglesworth, however, had Dundee connections. Niven was born in Brown Constable

The Courier Building.

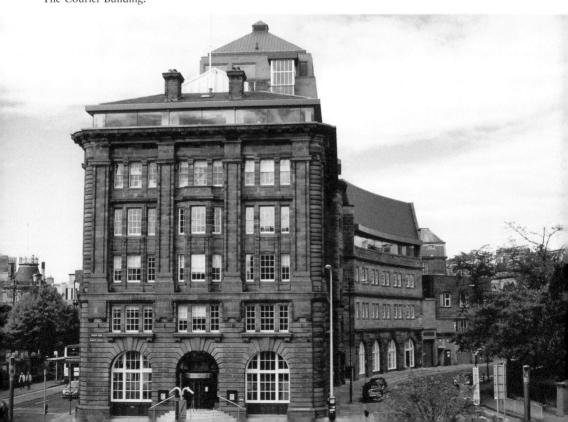

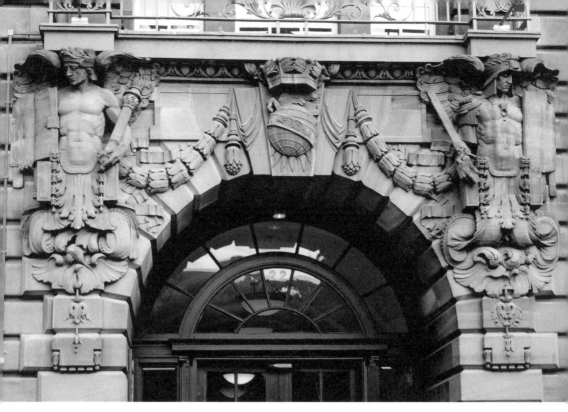

Meadowside entrance to the Courier Building.

Street and attended Dundee High School, while Wigglesworth's parents lived in and ran the family business from Dundee at around the time of the building's construction. It seems likely that Wigglesworth was the source of the American influence having undertaken a study tour of the United States in 1892.

By the time the Courier Building came to be constructed, the hazards of building on Dundee's marshy meadow lands were well known. A solution was also at hand, however, in the form of the type of reinforced concrete patented by French engineer François Hennebique, which saw its first use in Scotland in stabilising the building allowing it to rise to a greater height than other buildings in the area.

It has often been said that the idea for the long-running *Beano* strip The Bash Street Kids was inspired by looking out of the window and seeing the children in the playground of the High School below. The strip's inventor, the late Leo Baxendale, disputed this, however, saying that he came up with the idea while living in Preston.

The Courier Building is enhanced by Albert Hodge's sculptures of Literature and Justice at the Meadowside entrance and by the nine-storey tower added in 1960 by local architect Thomas Lindsay Gray, which maintained the American feel of the existing structure. In 2013, the Courier Building was closed for a major refurbishment. It re-opened in 2017.

34. The King's Theatre (1909)

The King's Theatre and Hippodrome in Dundee's Cowgate, which opened in 1909, soon became a regular stop for various touring outfits, from drama and opera companies to music hall and variety acts. The building was designed by Frank Thomson (son of City

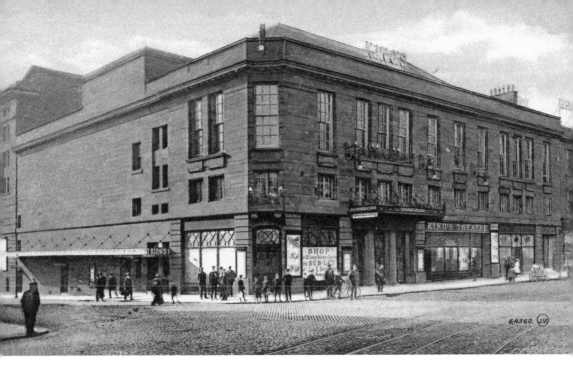

Above: Postcard view of King's Theatre.

Below: Recent view of King's Theatre building.

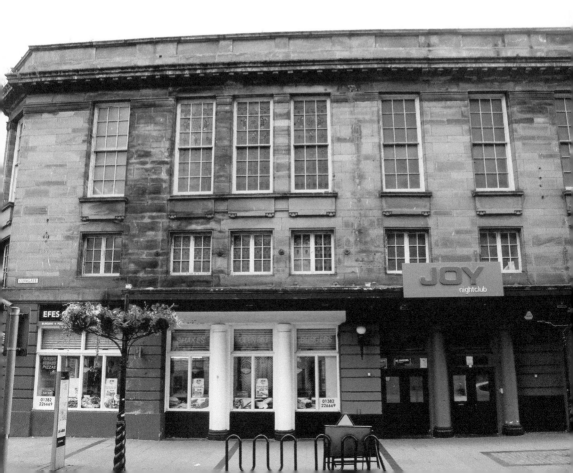

Engineer James Thomson) who had been recruited by his brother Henry for the task in 1906. At that time Frank was employed by Niven & Wigglesworth of London who, as we have seen, had been responsible for the Courier Building, and their influence can be seen in the theatre's exterior appearance.

The interior of the building, meanwhile, displayed all the grandeur and spacious opulence of a theatre built during the Edwardian period when luxurious surroundings were regarded as part of the experience of a night out. The large stage looked out onto two upper tiers – the circle and balcony – as well as private boxes. There was much decorative plasterwork and a fine ceiling with painted frescoes.

From its earliest days the King's had shown films via the 'Kingscope' as well as presenting live shows and conversely, after it became a cinema in 1927, live shows continued with Cliff Richard and The Shadows appearing there as late as 1959. Alterations in 1961, however, saw the removal of the stage. It was as a cinema, then, that many in Dundee today will remember the building, particularly as the Gaumont from 1950–1973 or as the Odeon from 1973–1982. Generations attended Saturday morning children's shows or queued to see such films as *The Sound of Music* or *Star Wars*, which made their Dundee debuts there.

Since its closure as a cinema the King's Theatre has been put to various uses including as a bingo hall, a bar and a nightclub. Recent years, however, have seen calls for it to be returned to its original function. While several alterations were made to the building over the years, many original features are thought to survive and it is to be hoped that one day this sadly neglected jewel can be restored to its former glory and once again take its place in the cultural life of Dundee.

35. Coldside Library (1909)

The first of Dundee's branch libraries was built at Lochee in 1894, thanks to a donation from Thomas Cox of textile business Cox Brothers. Four further branch libraries and the central reading rooms were opened in the early years of the twentieth century with the help of an even more generous benefactor – the Dunfermline-born industrialist and philanthropist Andrew Carnegie.

Carnegie's donation provided the cost of the buildings themselves but the sites were gifted separately. The first site chosen, which was gifted by a Miss Symers, was at Arthurstone Terrace. The foundation stone for the Arthurstone Library was laid by Carnegie's wife, Louise, in the presence of her husband on 24 October 1902. That same day Carnegie was presented with the Freedom of Dundee in a ceremony at the Kinnaird Hall.

The Arthurstone Library was opened in 1905 and proved to be so successful that plans were made to press ahead with further buildings. The site for the branch library to serve the expanding northern Dundee area at Coldside was the gift of former Lord Provost Charles Barrie. Barrie, who had represented the area on the council, had been born at Coldside in 1840 and the ground formed part of his family's property. Barrie's other well-known donation to the area was the Hilltown Clock, which he presented to the community in 1900.

The Coldside branch library was designed by James Thomson (who had been appointed City Architect in 1904), assisted by his son, Frank, and William Carless. The Edwardian Baroque building consists of a long concave front enlivened by a large section of red brick. It ends in two decorative gables at Strathmartine Road and Strathmore Avenue (or Loons Road as it was then known). The various sculptures are by Albert Hodge.

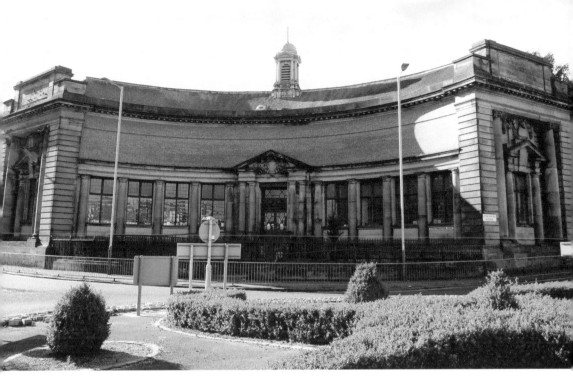

Above: Coldside Branch Library.

Below: Coldside Branch Library – detail.

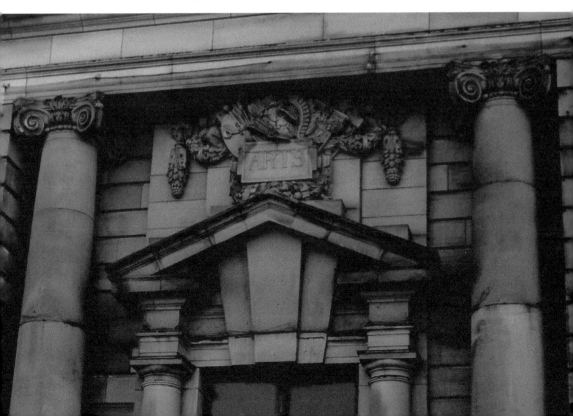

The reading rooms at Coldside were opened on 22 October 1908 by Edinburgh's Chief Librarian Hew Morrison in the presence of Lord Provost Longair. The lending library of some 6,000 books was formally opened on 9 April 1909 by Charles Barrie. The Coldside Library continues to serve the local area to this day.

36. Blackness Library (1909)

Very much a twin (if not an identical one) of Coldside Library, Blackness Library's reading room was opened on the same day in 1908 as that of its northern counterpart. The opening ceremony was performed by Dr John Ross, the Chairman of the Dunfermline Carnegie Trust, who, like Dr Morrison at Coldside, was presented with an inscribed silver key to mark the occasion. Ross described the building as 'a great addition to the architectural adornment of the city'. Also in common with Coldside, the lending library at Blackness was opened on 9 April 1909, this time by Lord Provost Urquhart.

Blackness Library shared an architect with Coldside in the shape of James Thomson, assisted by his son, Frank. The triangular site at the junction of Blackness Avenue and

Blackness Branch Library.

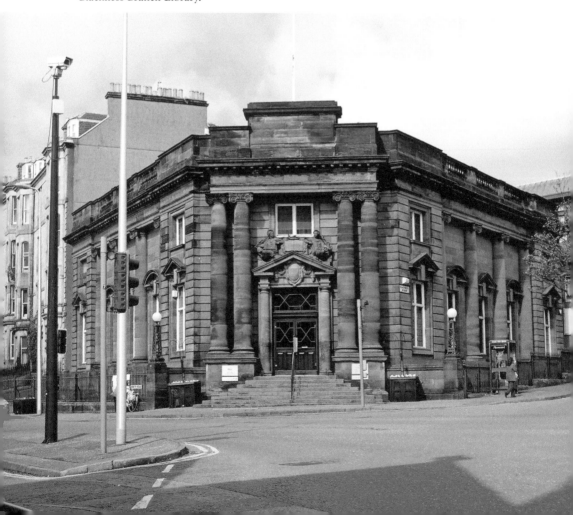

Perth Road meant that the design was necessarily different from Coldside but is no less impressive. The red sandstone building features two pairs of enormous Ionic columns at either side of the main entrance. Above the door are two figures of learning with an open book by the sculptor Albert Hodge. Inside are a pair of bronze plaques, one depicting John Robertson, who donated the site, and one of Andrew Carnegie himself.

37. The Caird Hall (1923)

Sir James Key Caird was a Dundee jute baron who had greatly expanded his family's business. He was also a philanthropist who, among other things, had provided funding for Ernest Shackleton's ill-fated Antarctic expedition. One of his most notable donations, though, was the sum of £100,000 to Dundee's council towards the building of a new City Hall and Council Chambers. The development was to change the face of central Dundee, removing the historic Vault and Greenmarket and ultimately leading to the demolition of the eighteenth-century Town House to complete the open view of the City Square.

The Caird Hall's foundation stones were laid remotely from Caird's Ashton Works in July 1914 by King George V and Queen Mary. It would be the best part of a decade, though, before the building was completed due to the outbreak of the First World War a few weeks after the royal visit. The opening ceremony finally took place on 26 October 1923 and was performed by the Prince of Wales (later King Edward VIII). By this time, James Caird had died. His sister, Mrs Emma Marryat, after whom the adjoining Marryat Hall is named, made a further donation of £75,000 towards the project.

Souvenir postcard from the opening of Caird Hall.

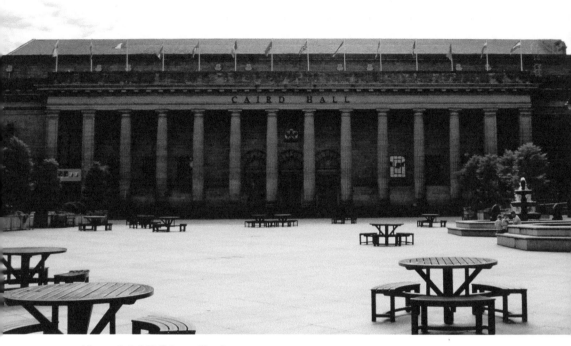

Above: Caird Hall from City Square.

Below: Caird Hall from Slessor Gardens.

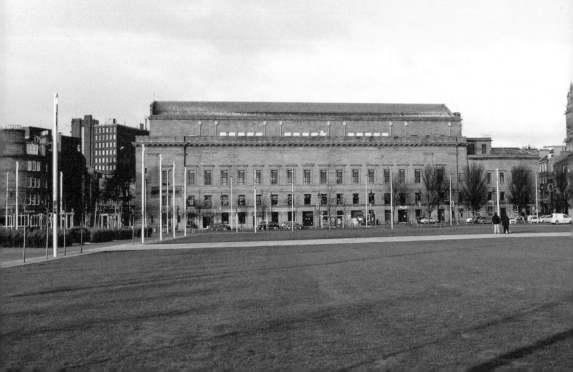

The most striking feature of the exterior of the building by City Architect James Thomson was the colonnade of ten Ionic columns with a set of two square pillars at either end. This gives the building a grim authority that led to it being chosen to double for Soviet-era Moscow in the 1983 TV drama *An Englishman Abroad*.

The interior was decorated to a high standard – from the marble-floored entrance vestibule to the fine decorative plasterwork – by Messrs H. H. Martyn & Company. The stage could accommodate a 75-strong orchestra with a choir of 300 in the chorus seats in front of the magnificent organ built by Harrison & Harrison of Durham. Among those to have graced that stage are Gracie Fields, Mario Lanza, Paul Robeson, Duke Ellington, Frank Sinatra, Bob Hope, The Beatles, The Who, The Rolling Stones, David Bowie and Elton John.

38. Whitehall Theatre (1929)

Yorkshireman Arthur Henderson was one of the pioneers of cinema in Dundee, having first shown silent films in Lochee and at a booth in Bellfield Street as early as the 1890s. In 1906, he opened the first of several cinemas in the city at premises in Wellington Street.

In 1929, Henderson opened the Alhambra Cinema in Bellfield Street. The Alhambra was designed by Frank Thomson and was built in brick, faced with white cement. The building work encountered some unexpected difficulties. The site had once been the Blackness

Whitehall Theatre as The Alhambra.

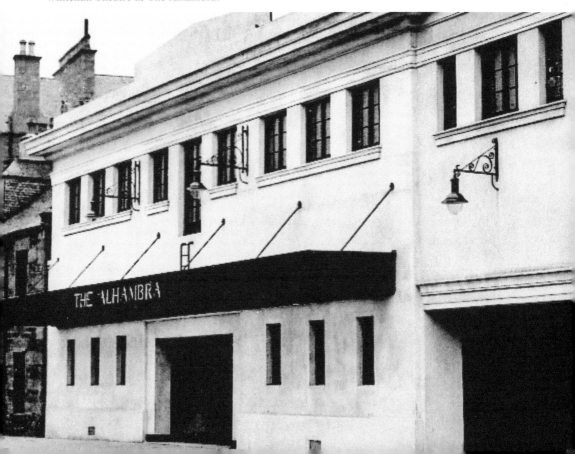

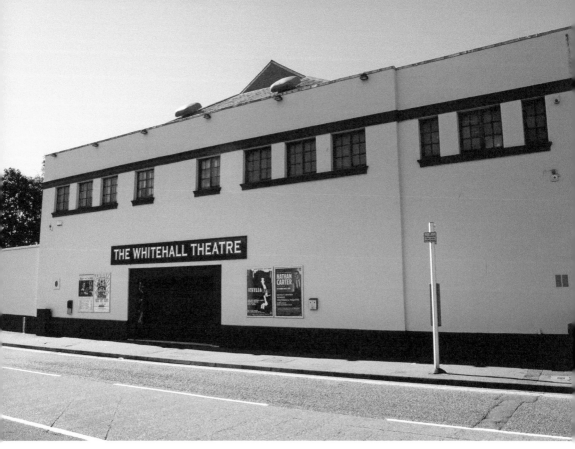

Whitehall Theatre today.

Quarry and in order to create the dressing rooms under the stage, it was necessary to bore down for a depth of 5 feet into solid rock. The building was furnished to a high standard and had a seating capacity of 1,050.

From the start, the Alhambra was intended to be used as a theatre as well as a cinema. Henderson announced that he did not intend to show talkies, having more faith in silent films and even more faith in live actors. Needless to say, he was forced to change his mind on talkies but in 1937 the Alhambra became a full-time theatre. It struggled to survive, though, and the building reverted to cinema use in 1939. Nevertheless, Robert Thornley, who led the last company to perform at the Alhambra, went on to found Dundee Rep the same year.

The Alhambra then passed through the hands of the two most famous cinema owners in Dundee. In 1940, it was sold to William Pennycook, who renamed it The State Cinema. In 1959 it came into the ownership of J. B. (James Bannerman) Milne's Picture House (Tayport) Ltd. Following Milne's death in 1968, The State was acquired by the Dundee Corporation and opened as the Whitehall Theatre the following year.

In 1982, a trust was set up to ensure the smooth running of the theatre. At the same time, the neighbouring Caledonian Halls were purchased and converted to improve facilities. The Whitehall Theatre continues today to stage professional and amateur plays and musicals, comedy shows and concerts.

39. Harris Academy, Perth Road (1931)

William Harris was born in Dundee in 1806 and attended the Grammar School before becoming apprenticed as a baker to his uncle. After some years in London he returned to Dundee, where he was elected to the town council. In 1881, he donated £30,000 for the purposes of Higher Education in Dundee on the condition that Dundee's High School remained free of School Board control. £10,000 of this went towards the foundation of Harris Academy.

The original school building was situated in Park Place and opened in 1885. The school soon outgrew the premises, however, and a competition was launched to design a new school at Perth Road. The winning design was by architects Thoms & Wilkie and work began on the site in 1926. The new school opened in 1931, while the Park Place building went on to become the first home of St John's High School.

The design of the new Harris Academy was adapted to the sloping site, meaning that there was a two-storey block to the north and a three-storey block to the south, while the main entrance was on the first floor and was reached by a bridge from Perth Road. The lower level took the form of a hexagonal courtyard around a central school hall.

This building was much extended and adapted over the years but by the early years of the twenty-first century it was considered to be inadequate for modern use and it was decided that it should be rebuilt. Pupils and staff temporarily moved to the former Rockwell High School at Lawton Road in 2013. Meanwhile, in 2015, it was announced that Menzieshill High School would close and its pupils transferred to the new Harris Academy.

The new school was designed by Holmes Miller and like its predecessor was shaped by the sloping location. The modern facility includes seventy-one classrooms, a games hall,

Harris Academy, built in 1931.

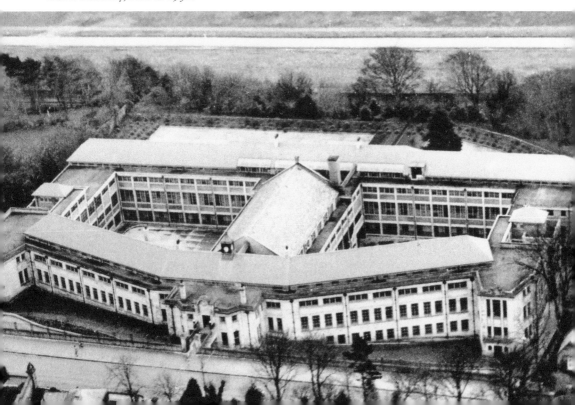

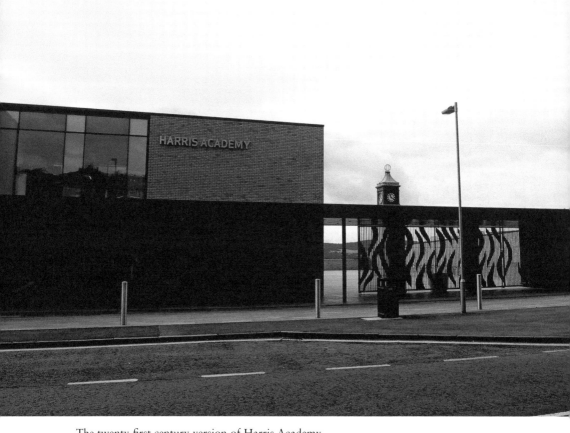

The twenty-first century version of Harris Academy.

dance and fitness studio, swimming pool, kitchen and training kitchen, recording studio and science hub. The historic clock tower and decorative stone entrance portico from the previous building have been adapted into the new design.

40. Mills Observatory (1935)

When the Dundee manufacturer John Mills died in 1889, his will left generous provision for several local institutions including the Infirmary and the *Mars* training ship. The residue of his estate, however, was devoted to one of his greatest interests. Mills had been a keen amateur astronomer and had had his own observatory on the lower slopes of the Law. He requested that his legacy be used for 'the erection and maintenance in my native Dundee or its suburbs' of a 'building of ornamental description … for the use of a telescope or telescopes', the use of which, he believed, 'would afford to the community an opportunity of observing the extent not generally within their reach, the wonders and beauty of the works of God in creation and would in so doing yield them rational and innocent entertainment of the highest kind'.

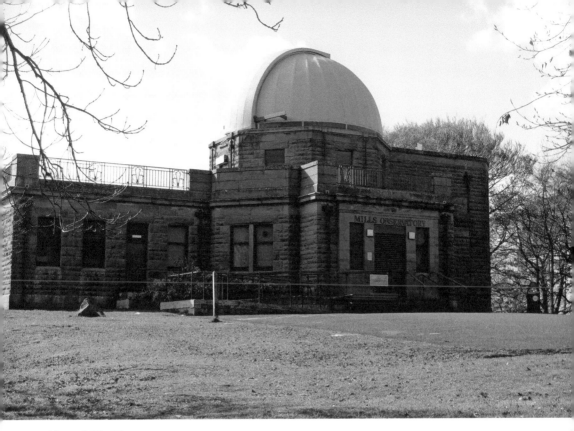

Above: Mills Observatory.

Below: Another view of Mills Observatory.

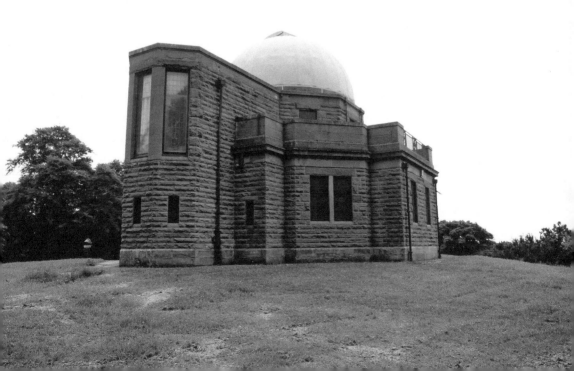

It was not until the 1930s, when public works were being used to counteract the effects of the depression, that work actually began on building the observatory. An earlier plan to place it on the summit of the Law was abandoned when the First World War broke out. The site was eventually devoted to a memorial to that war.

The Astronomer Royal, Professor Ralph Sampson, recommended that the observatory be built on Balgay Hill – a site which combined public accessibility with relative isolation from sources of artificial light. Sampson collaborated with City Architect James MacLellan Brown in the design of the building – a smart sandstone structure with a distinctive 7-metre papier-mâché dome. The Mills Observatory was opened in October 1935 and was the first such building in Britain to have been built for use by the general public.

The building underwent a major refurbishment in 2003. While still offering the public the chance to view the night sky through its telescopes, it also hosts exhibitions, lectures and planetarium shows. Outside, the Planet Trail provides a scale model of the solar system. In its mission to educate and entertain, the observatory continues to live up to the vision of John Mills.

41. Green's Playhouse (1936)

Cinema was at the height of its popularity throughout Britain in the 1930s, but was more popular in Scotland than elsewhere and nowhere was it more popular than in Dundee, where there was a higher proportion of cinema seats per person than anywhere else. It is no surprise then that in 1935 it was announced that a 'super cinema' was to be opened in the city with seating for more than 4,000 people.

The Green family owned a Playhouse Cinema in Glasgow and envisaged a chain of these throughout the country. Having purchased the ground between Nethergate and Yeaman Shore, the Greens brought in John Fairweather – who was responsible for the Glasgow cinema – to design the Dundee one.

The sheer scale of the Playhouse was unlike anything seen in the city before, with seating for more than 2,500 in the stalls and in excess of 1,500 in the balcony and boxes. Despite this, it was reported that the building was 'far from overpowering in its vastness'. Views of the screen were good throughout and a 30-ton girder supporting the balcony meant that there were no pillars. The facilities also included a 200-seat café and a make-up room for female visitors.

The décor was luxurious throughout, as the vast terrazzo entrance foyer leading to a marble staircase immediately suggested to the visitor. Indeed, the Greens had hoped to replace the Nethergate pavement with an extension of the terrazzo but were refused permission. They were, however, allowed to build the 85-foot-tall steel-and-glass tower with the cinema's name in neon letters. The letter 'u' sat out of kilter – 'We want 'u' in' being the Greens' slogan. Another slogan, 'It's Good – It's Green's', was woven into the building's custom-made carpets.

Like many cinemas, the Playhouse turned to bingo as attendances declined, becoming a Mecca Bingo hall in 1970. It was around this time that the tower was clad in sheet metal. A devastating fire in 1995 destroyed the building and it was rebuilt with only the restored tower remaining as a symbol of its former greatness.

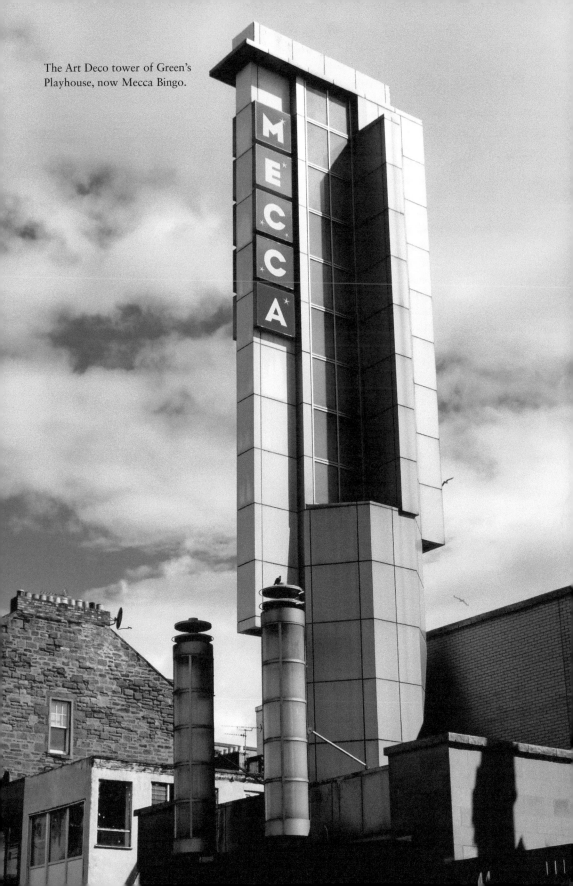

The Art Deco tower of Green's Playhouse, now Mecca Bingo.

42. Dallfield 'Multis' (1966)

Dundee's first dalliance with high-rise living was 'Robertson's Land', a nine-storey tenement built in 1870 between Walton Street, Urquhart Street and Larch Street. The experiment was not a success, however, and a year after it was built the City Improvement Act prohibited tenements of more than four storeys.

It was to be almost a century before domestic buildings in Dundee would reach such dizzy heights again, when a number of multi-storey blocks (commonly referred to in Dundee as 'multis') were built in the 1960s and '70s. The demand for new housing in this period was great as slums were cleared and 'streets in the sky' were considered to be the perfect solution.

When Dundee's first ten-storey blocks were built at Dryburgh in 1960, many who moved in were certainly entering houses that were far superior to those they had left. Other, taller developments followed, including those at Menzieshill, Ardler, Alexander Street, Trottick, Derby Street, Whitfield and South Road. By the early 1970s the Dundee multis were home to thousands and there were more than fifty blocks in the city.

Even as some of these were being built, however, a gas explosion saw the partial collapse of a London tower block, Ronan Point. This led to tougher building regulations but was the beginning of the erosion of public confidence in high-rise housing. Many questioned its suitability for family living and as occupancy decreased, problems with vandalism

Dallfield 'multis'.

Bonnethill Court.

increased in some blocks. It seemed that the multis had failed to live up to the high hopes placed in them and most of Dundee's blocks have now been demolished.

The Dallfield multis comprise the largest surviving development and consist of four fifteen-storey blocks – Dallfield Court, Tulloch Court, Bonnethill Court and Hilltown Court. They were built by the Scottish Construction Company between 1964 and 1966. Nestling at the foot of the Hilltown, they are both more central and less exposed than their former neighbours at Alexander Street and Derby Street and maintain a sense of connection to the surrounding area that other developments lacked.

43. Olivetti Building (1972)

In the post-war years, the nature of work began to change for many in Dundee. While the traditional industries such as jute manufacture and shipbuilding continued, they were in long-term decline and newcomers to the city, such as Timex, Ferranti and NCR, seemed to represent the future. Not only did these companies deal with more modern technologies, they tended to be based in out-of-town industrial estates. Few of their buildings would merit a second glance from a passer-by but the former Olivetti Building at the junction of Harrison Road and Faraday Street is an exception to the rule.

Olivetti were the Italian manufacturers of typewriters and other office equipment. They wanted a building that would reflect the stylish, contemporary nature of their products and turned to the Cullinan Studio of London, who produced a striking design. While it appears to be unique, the building is, in fact, one of four similar buildings built by Cullinan for Olivetti at this time. The others are located in Belfast, Carlisle and Derby.

The former Olivetti Building, now Hutchison Innovation Centre.

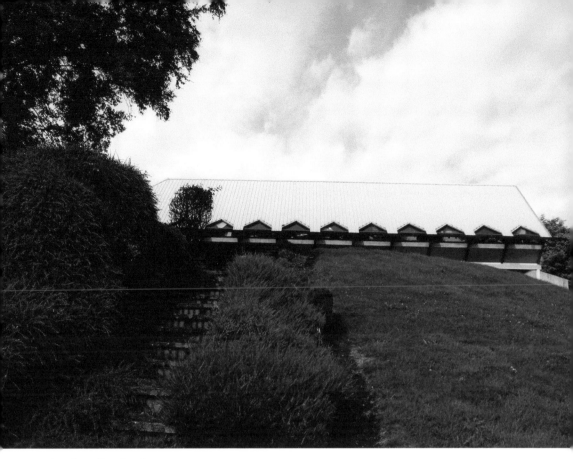

View from Faraday Street.

All four buildings were based on a combination of bespoke and standard elements. The ground floor of each structure was formed of concrete cast on site. This was built around a landscaped courtyard which helped to break up the dreary industrial estate surroundings. The design also allowed for future expansion. The Dundee building, for example, only surrounds two and a bit sides of the courtyard – the intention being that it could eventually expand to form a quadrangle if required. The pitched roof was created using a prefabricated system of plywood trusses, supported by a light steel frame and a series of timber fins.

All four Olivetti buildings survive, though some of them have been much adapted over the years. The Carlisle building was a Chinese restaurant for many years and was later converted into a carpet showroom – proof, if it were needed, of the adaptability of the design. The Dundee building appears very much intact, though like the others its original roofing material has been replaced. It is now home to Hutchison Technologies Ltd.

44. The Rep (1982)

Dundee Repertory Theatre was founded in May 1939 by Robert Thornely, the Lancashire-born leader of a theatrical touring company that included future film star Richard Todd. The company had been playing Dundee's Alhambra Theatre at the time that it reverted to use as a cinema and Thornley saw the need for a permanent theatre in the city. By December of that year the venture had found a home in the Foresters Hall in Nicoll Street.

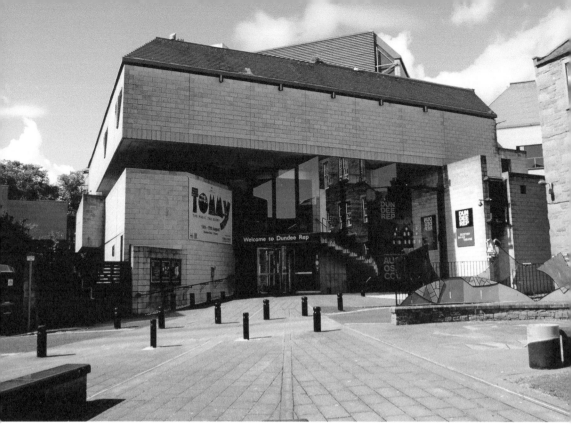

Above: Dundee Rep.

Below: Dundee Rep extension.

The Rep continued to be housed in Nicoll Street until June 1963, when a fire devastated the building. By October that year, what was intended to be a temporary home had been found in the former Dudhope Church at Lochee Road. It was not until 1979, however, that work began on purpose-built premises on land at Tay Square donated by Dundee University, with the foundation stone being laid by the University's former rector, Peter Ustinov. The building process was beset with funding and technical difficulties but was eventually completed with help from a successful public appeal.

The new theatre opened on 8 April 1982. The building was designed by the then newly formed Dundee-based architects Nicoll Russell Studios. Despite its decidedly modern appearance the Rep fits seamlessly into the Georgian square, with the two-storey glass frontage helping to draw the audience into the venue. Once inside, the foyer links all the public spaces that surround the auditorium. The 450-seat auditorium is set out so that even the furthest back seats feel close to the stage.

There have been various extensions and refurbishments at the Rep, all carried out by Nicoll Russell Studios in a manner sympathetic to their original design. Perhaps the most significant was the creation in 2004 of a dance studio, changing rooms and support accommodation for the Scottish Dance Theatre, which had begun life as Dundee Rep Dance Company in 1986. The Rep now boasts a company of more than twenty performers. A feature of Dundee life for more than seventy years, it is easy to forget that few places are blessed with such an outstanding cultural facility.

45. Dundee Contemporary Arts (1999)

The site between St Andrew's Roman Catholic Cathedral and Nethergate House was once part of the town's medieval hospital. In the late nineteenth century, shop units there had various occupants, including the photographers Valentine & Co. For much of the twentieth century it was occupied by a garage. After this closed in the 1980s the site fell into disrepair and was used as an informal skateboard park.

In the mid-1990s Dundee Council acquired this unlikely site for what many thought was an equally unlikely project – a new contemporary arts centre which brought together a printmakers' studio, a visual arts research centre, a two-screen cinema and a modern art gallery space.

Edinburgh firm Richard Murphy Architects won the ensuing design competition in July 1996. The resulting building was described by the *Sunday Times* as 'one of the most satisfying, sublime and stylish public buildings opened in years'. The site presented several restrictions, from the narrow street frontage to the drop from front to back, but these had not only been overcome but used to the building's advantage.

Rather than replicate the street frontage of the garage premises, the entrance foyer was set back from the road to give a sense of open public space. Imaginative use was made, too, of parts of the brickwork of the garage warehouse, with the new building appearing to have been inserted into the shell of the old.

The interior saw the café placed at the heart of everything with all the activities grouped around it and easily accessible from it – so that a visitor who may only have come for a coffee might be tempted to see an exhibition or a film.

Dundee Contemporary Arts (DCA) opened in 1999 to much critical acclaim for the building but much scepticism as to whether the people of Dundee would make use of such

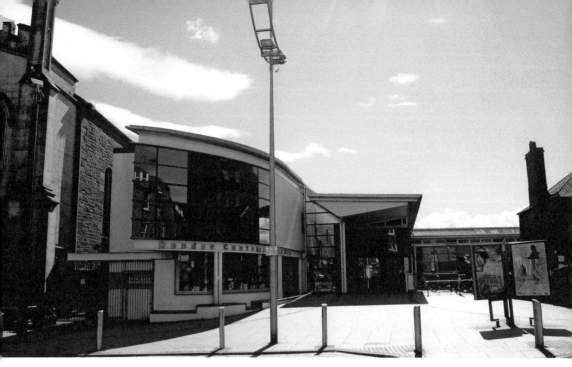

Above: Dundee Contemporary Arts (DCA).

Below: DCA from the Greenmarket.

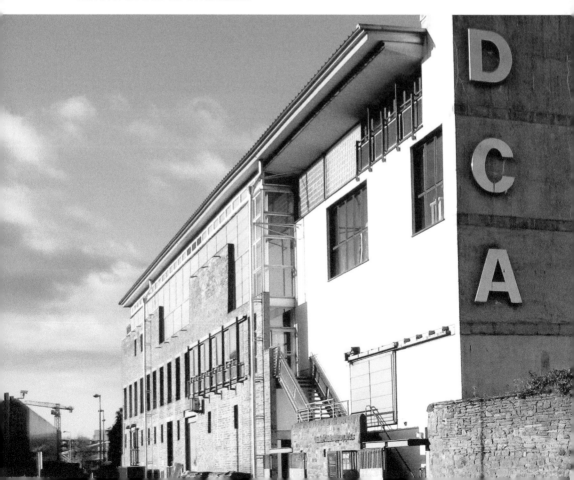

DCA Nethergate entrance and garden.

a facility. Nonetheless, the centre has proven to be a success, with visitor numbers much higher than anticipated. Today, together with the Rep Theatre, it is one of the cornerstones of what has been branded Dundee's cultural quarter.

46. Overgate Centre (2000)

The suffix 'gate', which is to be found on several Dundee place names, was originally 'gait' or 'gaet', meaning a road. Two of the town's oldest streets were Argylesgait and Flukergait (later renamed the Overgait and Nethergait, or the 'High Road' and the 'Low Road'). The Overgait stretched from the High Street to the West Port and contained many historic structures, including the building that had been occupied by General Monck in 1651 and had been the birthplace of Anne Scott, 1st Duchess of Buccleuch.

While it had once been home to nobility, in the wake of the Industrial Revolution in the nineteenth century the Overgate had become a heavily populated working-class area which later fell into disrepair and disrepute. Three proposals were made to redevelop the Overgate in the early years of the twentieth century but none came to fruition. The years after the Second World War, however, saw people move out of the city centre to new housing developments and fresh plans were drawn up to clear what was considered a slum area. The mindset of the 1960s saw no room for compromise in the pursuit of modernity

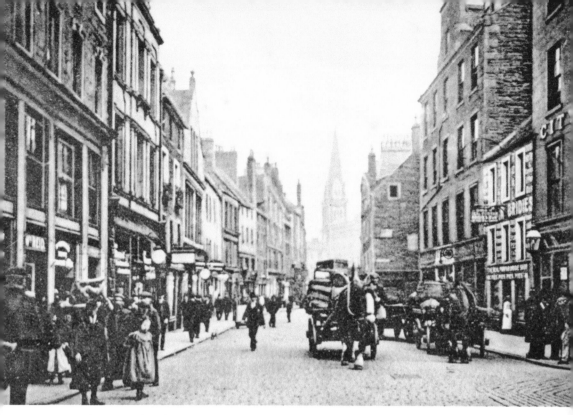

Above: Dundee's historic Overgate.

Below: The Overgate Centre.

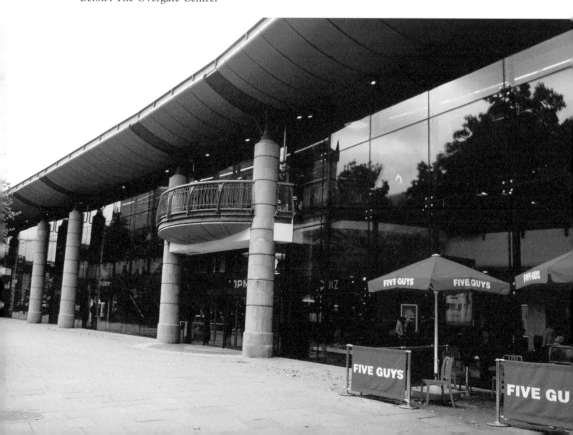

and no aspect of the old Overgate was retained. Ancient streets such as Tally Street, Thorter Row and Mid Kirk Style were swept away and traditional north/south routes closed.

The new Overgate Centre designed by Ian Burke, Hugh Martin & Partners was a two-storey open-sided concrete shopping centre with a car park on top. Though it was a popular shopping venue in its early years, the opening of the Wellgate Centre in the 1970s accelerated the Overgate's decline and the western part of the centre became underused. A new version of the Overgate Centre was built between 1998 and 2000 with Benoy as conceptual architect and Keppie Design as executive architects. It retained the multistorey office block City House and refurbished the eastern part of the existing centre. The 420,000 square feet of retail space, containing seventy retail units, was enclosed behind a curved glass frontage that was more sympathetic to the surrounding area than its predecessor.

47. Dundee Central Mosque (2000)

In 1969, Dundee Islamic Society began to meet and worship in a ground floor flat at No. 5 North Erskine Street. As the numbers attending increased, however, the neighbours began to complain about the disturbance. It became clear that new, larger premises would

Dundee Central Mosque.

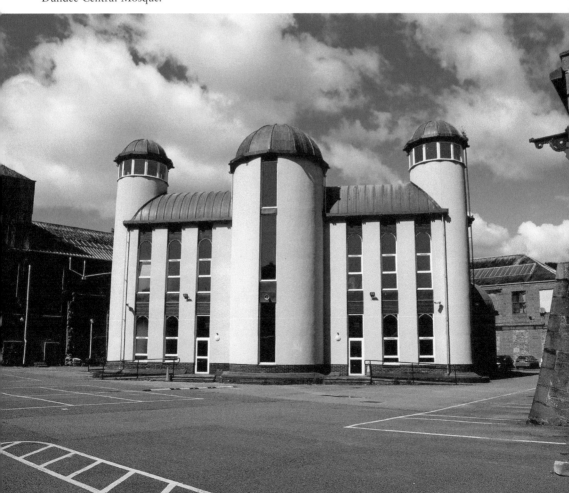

be needed and the red-brick fronted offices of the former Hillside Works at Nos 112–114 Hilltown were acquired.

In 1995, at a cost of £212,000, a site was purchased for a new purpose-built mosque at No. 6 Miln Street (entering from Brown Street). The mosque was designed by the Fife-based Lucas Dow Design Studio and opened in 2000, with the majority of the £2-million cost being raised by the local community. The design provides a modern take on traditional Islamic architecture, while employing local materials and energy efficient construction techniques. It is built of smooth cream stone topped with a rounded copper roof and has a tower or minaret on each corner. The mosque is designed to face Mecca to the south-east. The male prayer room is located on the ground floor with the female prayer room above, providing accommodation for around 1,000 worshippers in total.

48. Maggie's Centre (2003)

It is truly remarkable that the world-renowned architect Frank Gehry, responsible for buildings such as the Guggenheim Museum in Bilbao, should have designed a building in Dundee as his first in the United Kingdom. Even more remarkable is that this was not a large-scale city centre project but a small cancer centre in the grounds of Ninewells

Maggie's Centre from the garden.

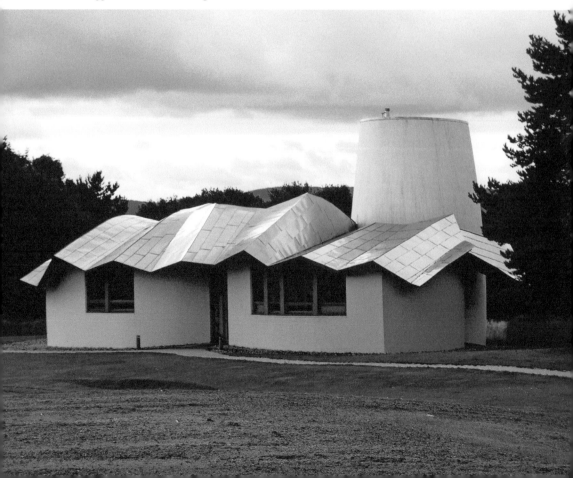

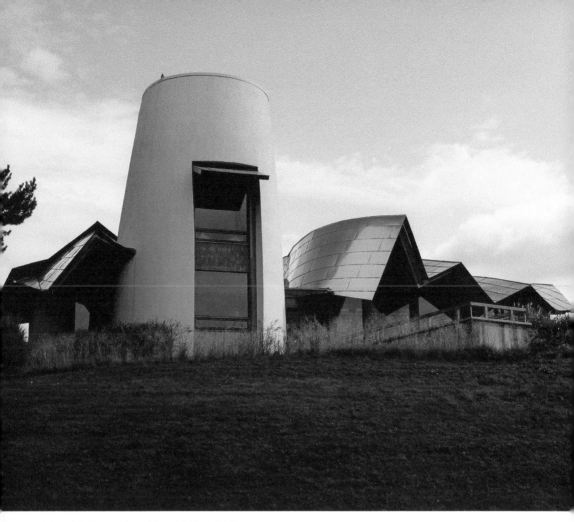

Maggie's Centre from Tom McDonald Avenue.

Hospital. The reason for Gehry's involvement was his longstanding friendship with a woman named Maggie Keswick Jencks.

Maggie Jencks spent the final months of her battle with cancer developing ideas for a new type of care whereby patients in her situation would have a well-designed, comfortable, non-clinical space where they could find practical advice and meet and support others. The first such centre, designed by Richard Murphy, was opened in Edinburgh in 1996, followed by one in Glasgow in 2002. Sadly, Maggie did not live to see these opened as she died in June 1995.

Gehry's Dundee building with its distinctive undulating roof is a white, cottage-like structure, modelled on a traditional Scottish 'but 'n' ben' and as such immediately brings things down to the more human, domestic scale that Maggie envisioned. It won the Royal Fine Art Commission for Scotland's Building of the Year award.

Maggie was a garden designer and so it is fitting that the surrounding landscape is an integral part of the centre. The garden, designed by Arabella Lennox-Boyd, contains a labyrinth design. Symbolically, though, it is not a maze and there are no dead ends and there is always a way through. Also in the grounds of the centre is a sculpture by Antony Gormley, entitled 'Another Time X', one of his famous series of human figures.

The success of the design of the Dundee centre and the involvement of Frank Gehry gave a new impetus to the overall project and an added prestige to involvement in it. Other renowned architects such as Zaha Hadid, Richard Rogers and Norman Foster all went on to design Maggie's Centres, each providing the kind of safe, relaxed environment for cancer patients that Maggie Jencks imagined.

49. Building 01, District 10 (2014)

Dundee has a history of being a centre of creative industry stretching back at least as far as the birth of *The Beano* and *The Dandy* comics in the 1930s. More recently, the city has been associated with computer gaming, having achieved fame in the 1990s as the birthplace of games such as *Lemmings* and *Grand Theft Auto* and as the first place in the world, courtesy of Abertay University, to offer a degree in the subject.

Creative industries have continued to thrive in the city and so it is fitting that as part of the waterfront redevelopment a Creative Media District has been set aside at Seabraes Yards. Known as District 10, the area is specifically designed for companies at an early stage in their development.

The first building to be opened, the appropriately named Building 01, manages to combine innovation with flexibility and sustainability. It is constructed from thirty-seven recycled shipping containers. There are fifteen office units as well as a meeting room and shared kitchen facilities. Most of the containers are used to form the offices, each of which

Building 01, District 10, looking south.

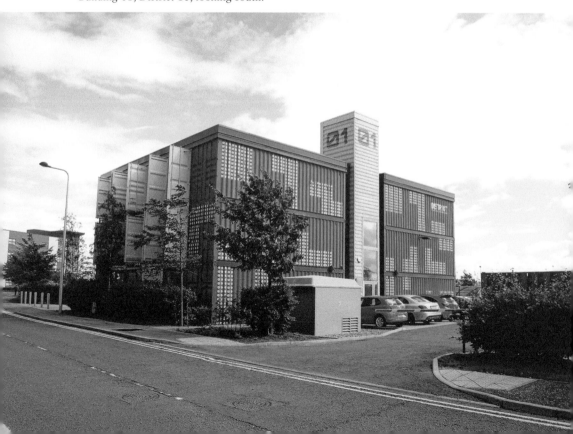

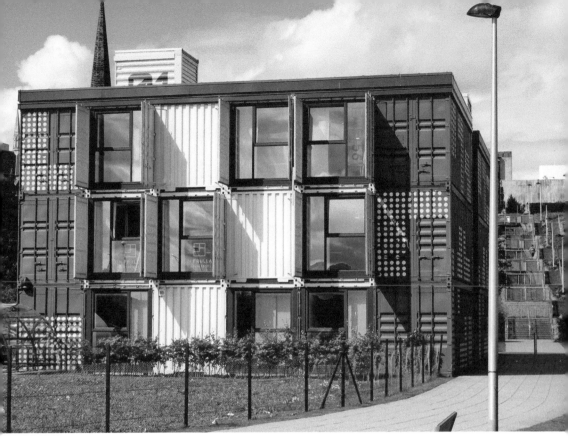

Building 01, District 10, looking north.

can comfortably accommodate up to four people. An upturned container, meanwhile, forms the building's entrance lobby.

50. V&A Museum of Design Dundee (2018)

In 1844, Queen Victoria and Prince Albert arrived at Dundee. A few years later a permanent monument of their visit was erected in the shape of the decorative Royal Arch, which stood at the entrance to the docks for more than a century before being demolished in the 1960s as part of the redevelopment of the area to make way for the Tay Road Bridge.

The bridge may have improved transport to Dundee but as the decades passed the realisation dawned that the associated road system had cut off the city from its fine natural setting by the river. As the new millennium dawned, a comprehensive thirty-year plan was drawn up for the redevelopment of the waterfront area. The centrepiece was to be a building which brought Victoria and Albert's name back to the area – the V&A Museum of Design Dundee. This was to be the UK's first design museum to be built outside London and the first time that the Victoria & Albert Museum allowed use of its name elsewhere. The new museum, built on the banks of the Tay, would host major exhibitions from the V&A collection, celebrate Scotland's design heritage, and encourage innovation.

Above: The V&A Dundee under construction.

Below: The V&A takes its place beside the *RRS Discovery*.

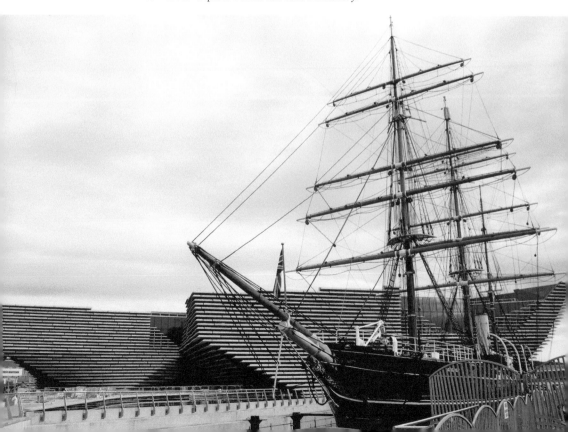

An international architectural competition attracted more than 120 entries. The winning design by Japanese architects Kengo Kuma & Associates takes full advantage of the setting, with one corner projecting out into the water like the prow of a boat. An opening in the middle of the design aligned with Union Street seeks to connect the river with the centre of the city.

Construction work on the three-storey building began in March 2015. The external walls are fashioned in concrete in twenty-one separate sections – none of which are straight. In order to create the appearance of a Scottish cliff face, the walls are decorated with 2,500 pre-cast rough stone panels, each weighing up to 3,000 kg.

With the increase in visitor numbers that the V&A Museum of Design brings and the consequent cultural and economic benefits to the city, Dundee can surely look optimistically to the future.

Acknowledgements

All the modern photographs were taken by me and the older images are from my own collection, with the exception of the photograph of Gardyne's Land on page 12, which is courtesy of Messrs Simpson & Brown, architects. Thanks also to Revd Clive Clapson and the volunteers at St Salvador's Church.

Select Bibliography

Archibald, Malcolm, *Dundee at a Glance*, Fort Publishing Ltd (2016).

Dorward, David, *Dundee Names, Places and People*, Mercat Press (1998).

Gifford, John, *The Buildings of Scotland: Dundee and Angus*, Yale University Press (2012).

Jones, S. J. (ed.), *Dundee and District*, British Association for the Advancement of Science (1968).

McKean, Charles and Walker, David, *Dundee: An Illustrated Introduction*, Royal Corporation of Architects/ Scottish Academic Press (1984).

McKean, Charles, Whatley, Patricia and Baxter, Kenneth, *Lost Dundee*, Birlinn (2008).

Millar A. H., *Glimpses of Old and New Dundee*, Malcolm MacLeod (1925).

RCAHMS, *Dundee on Record*, HMSO (1992).

Walker, David M., *Dundee Architecture and Architects 1770–1914*, Abertay Historical Society (1977).